IMAGES
of America

ALEXANDRIA

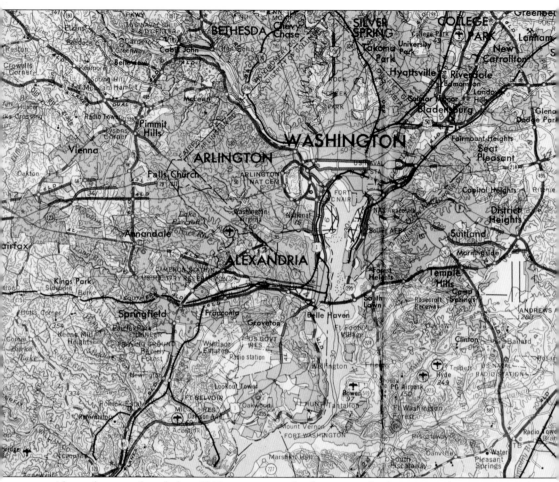

Alexandria was founded in 1749 as a seaport by farmers and tobacco merchants. Many of its original buildings remain standing. The city borders Fairfax County to the south and west and Arlington County to the north and northwest. The Potomac River separates it from the District of Columbia on the east. (Courtesy of Alexandria Library, Special Collections.)

ON THE COVER: Visual and historical evidence suggests that this diverse group was associated with a Freedman's Bureau school at 321–323 South Washington Street. The gathering, featuring men and women from virtually every racial and social background, was emblematic of the changes after the Civil War in the seaport city. This double house was built in 1859 for wealthy china and glass merchant Robert H. Miller as a wedding gift to his son, Elisha. (Courtesy of Alexandria Library, Special Collections.)

IMAGES
of America

ALEXANDRIA

George K. Combs, Leslie Anderson,
and Julia M. Downie

ARCADIA
PUBLISHING

Copyright © 2012 by George K. Combs, Leslie Anderson, and Julia M. Downie
ISBN 978-0-7385-9238-1

Published by Arcadia Publishing
Charleston, South Carolina

Printed in the United States of America

Library of Congress Control Number: 2011944188

For all general information, please contact Arcadia Publishing:
Telephone 843-853-2070
Fax 843-853-0044
E-mail sales@arcadiapublishing.com
For customer service and orders:
Toll-Free 1-888-313-2665

Visit us on the Internet at www.arcadiapublishing.com

CONTENTS

ACKNOWLEDGMENTS

The authors would like to thank Rose T. Dawson, director of libraries, and deputy director Linden Renner for their support, encouragement, and leadership on this and other projects. We also want to thank Dr. Pamela J. Cressey, director of Alexandria Archaeology; Wally Owen, senior curator at Fort Ward Museum; and Audrey P. Davis, senior curator at Alexandria Black History Museum, for the expertise they so generously share with the community. We are indebted to T. Michael Miller, former city historian and a man who has devoted much of his life to bringing Alexandria's past to light. We also wish to acknowledge William Francis Smith, a longtime friend of special collections who has donated thousands of images to the library.

Mark Zoeter, our unflagging and unflappable library assistant, deserves kudos for going beyond the call of duty on countless occasions. Also, former reference librarian Lara Otis, in her too-few days with special collections, organized a collection of images related to Alexandria's African American community.

We wish to acknowledge the volunteers who have given extensively of their time and talent, especially the Friends of Local History, which promotes the acquisition and sharing of information and materials in special collections. We are grateful to preservationist, researcher, and writer Tim Denee for bringing the cover photograph to our attention.

We wish to offer special thanks to the thousands of residents and visitors in Alexandria who have generously donated their stories and keepsakes to the Alexandria Library, Special Collections. It is their continued willingness to share that makes our work both fulfilling and fun. Unless otherwise noted, all images are the property of Alexandria Library, Special Collections.

George K. Combs, MSLS, Branch Manager, Special Collections
Leslie Anderson, MSLS, Reference Librarian
Julia M. Downie, MSLS, Images Librarian

INTRODUCTION

Recent archaeology in Alexandria has revealed traces of Paleo-Indian civilization. Before European contact, Late Woodlands Indians lived along the shores of the Potomac, sustained by the bounty of the river and the surrounding marshlands and forests. This seaport town was established on the river's south shore, on a gentle bay backed by a low bluff and bounded by the swampy Ralph's Gut to the north and Great Hunting Creek to the south.

Virginia's early purpose was tobacco cultivation. Settlers pushed up the Chesapeake Bay from Jamestown, felling and clearing trees in order to plant more acres of *nicotiana*. Their domestic animals, pests, and diseases permanently changed the landscape. By the 1730s, a tobacco inspection station was established at what would become West's Point. Settlement and interest in land west of the Appalachians required a town on the Potomac River. Alexandria had a deepwater port for seagoing vessels and access to the region's many tobacco growers. From its inception in 1749, the town was a place of merchants, commerce, trade, and business.

Alexandria became the prime regional location for shipping tobacco and purchasing goods. George Washington's Mount Vernon estate was less than 12 miles downriver, and he maintained a small house in town. Natural resources were conducive to growth: plenty of fresh water, timber for building, and clay for brick making. The population of Africans and African Americans—free and enslaved—was engaged in the city's development. There were black carpenters, joiners, painters, potters, musicians, cooks, and hostlers. Though many individuals are not remembered, they were integral to the city's growth.

In 1755, Gen. Edward Braddock's troops arrived in Alexandria intent on denying the forks of the Ohio River—modern-day Pittsburgh—to the French. One of his officers was a local notable, Col. George Washington. On July 9, General Braddock's troops were ambushed not far from their objective, and the contretemps ended in bloody ruin. Braddock Road in Alexandria marks the British Army's route, and a cannon marks the spot where they set out.

Alexandria was the seat of Fairfax County and the most important port on the upper Potomac. There was a hospital for Continental soldiers and a supply center for George Washington's beleaguered forces during the Revolution. Many Alexandrians served against the British. While the Royal Navy patrolled the lower Potomac and even visited Mount Vernon, Alexandria had only one brief brush with the Redcoats. A Royal Marine cutting-out party came upriver in small boats to seize shipping before being discovered and chased off. In 1783, the French army of the Count de Rochambeau encamped just north of the city and marched north after the British surrender at Yorktown.

After the Revolution, Virginia's fortunes stagnated. The tobacco monoculture had depleted the soil. Poor management led to erosion and the silting up of many ports and rivers. Many Virginians were cash poor and debt ridden. Some migrated across the Appalachians to Kentucky, Tennessee, and Missouri. Farmers switched from tobacco to grain, and eventually, Alexandria became a prosperous exporter of flour. During the Napoleonic Wars, the British Army in Portugal carried out a "scorched earth" strategy, which required large shipments of grain to feed themselves and

the Portuguese people. Much of that grain came through Alexandria. This close relationship with British markets made the War of 1812 unpopular with residents. It became even less popular in August 1814, when a British naval squadron took possession of the town and carried away all the goods and stores it could lay its hands on. Alexandria's surrender was unfairly compared to the spirited defense later waged in Baltimore. But Alexandria had no Fort McHenry to protect and defend against British warships. The District of Columbia had been burned days earlier. The Alexandria militia was north of the Potomac, and Mayor Charles Simms chose to surrender rather than see his city destroyed.

From 1791 until 1847, Alexandria was part of the diamond-shaped District of Columbia. Merchants and traders hoped that being part of the nation's capital would be good for business, but the federal government concentrated its operations north of the river. Due to limited business prospects, ties to its native Virginia, and a desire to protect the institution of slavery, Alexandria requested to be returned, or retroceded, to Virginia. Retrocession took place in 1847, but the return did not herald a new era of economic prosperity.

On the morning of May 24, 1861, Union forces invaded Alexandria. For four years, the city served as a logistics center for the Union effort in the east. Supply-laden trains and barges left Alexandria to support troops in the field. Much of the city became hospitals, encampments, prisons, and barracks. Bakeries produced millions of pounds of bread and crackers. Many city residents fled south. The city was transformed into a vast encampment with many new businesses and many, many armed men. There was murder and mayhem. And not all of the businesses were necessarily new, as prostitution, liquor sales, and gambling thrived. One of the first executions of a Union soldier during wartime took place in Alexandria. Private William F. Murray was convicted of shooting and killing Alexandrian Mary Butler. He was hanged for it in August 1861 at Fort Ellsworth, the current site of the George Washington Masonic Memorial.

Thousands of enslaved people from across Virginia made their way to Alexandria. Wherever the Union army advanced, freedom seekers followed. Many put down roots in the area. Business and industry—bakeries, fisheries, railroad, wharves, and shipbuilders—needed workers, so the free and freed built communities and created opportunities for themselves and their families. US Colored Troops (USCT) were stationed and trained in Alexandria, and many died and were buried here. Quaker educators and the Freedmen's Bureau started schools for destitute whites and offered a number of services to the displaced: rations and clothing, relocation assistance, legal protection, and more. In just a few years, African American businesses were not uncommon. The many black churches founded during this period became the backbone of Alexandria's African American community.

The city on the Potomac cycled between poverty and prosperity. A torpedo factory was built along the waterfront during World War I. The Virginia Shipbuilding Company created a shipyard from the ground up at the south end of town at Jones Point. The yard employed hundreds of workers but was never truly successful. Its first ship, the SS *Gunston Hall*, was not launched until the end of the war. The peacetime economy could not support the yard, and the company closed just a few years after opening. Over the next several years, Ford automobiles and Curtiss flying boats were built in Alexandria. An influx of Eastern Europeans added a new thread to the local tapestry, and Alexandria's long-standing Jewish community grew and encouraged greater diversity.

During World War II, Alexandria's torpedo factory was busy again, and the Pentagon's presence meant that government workers needed housing. Thousands of military personnel relaxed at the USO club near the corner of King and Washington Streets. German prisoners of war were detained and debriefed south of town at Fort Hunt. Farther south, Fort Belvoir was a major training ground for army engineers, and servicemen from all of these posts depended on Alexandria for rest and relaxation. After the war, Alexandria continued to grow as more and more federal civil servants found the community a good place to raise their families. The torpedo factory became a records center for German papers and materials seized during the war. The city was home to federal employees, elected officials, and appointees. Men as varied as Dr. Wernher von Braun, Congressman Gerald R. Ford, and Supreme Court justice Hugo Black all called Alexandria home.

One

ORIGINS AND EARLY YEARS

More than 13,000 years ago, Paleo-Indians hunted along the margins of the upper Potomac River and throughout the surrounding grasslands. Their descendants, generations of Algonquian-speaking Indians, continued to migrate with the seasons. In 1608, John Smith led an expedition from Jamestown to the Great Falls of the Potomac. He created a map that noted a sizeable Indian village along Great Hunting Creek just south of present-day Alexandria. Cavaliers and pioneers arrived in greater numbers and grew prosperous from growing tobacco. Newly established towns and villages permanently altered the local ecosystem.

As the population advanced along the Chesapeake Bay, the need for a port town near the head of navigation on the Potomac River became increasingly urgent. Hence Alexandria was founded in 1749 just north of Great Hunting Creek in Fairfax County. The town was marked off in a grid of 84 half-acre lots. Most were purchased by merchants and then subdivided.

Commerce flourished. The English bought tobacco and residents bought trade goods. As the American Revolution approached, grain replaced tobacco as a cash crop, and the expansion of turnpikes and railroads strengthened urban-rural ties. In the years after the war, Alexandrians were strongly Federalist. But as the town's slave trade grew and enslaved people were sold to points south in increasing numbers, Alexandria's rough-and-tumble reputation grew.

Shipbuilding, milling, and shipping were important industries. Though prosperous enough, Alexandria would never rival larger and better-situated ports like Baltimore and Norfolk. However, its growth called for institutions of learning and public progress. The Alexandria Lyceum opened in its new hall in December 1839. Schools and academies opened throughout the small city. Its proximity to Washington, DC, meant that many government officials and employees enrolled their children in Alexandrian schools—people as different in background Robert E. Lee and Mary Surratt.

Although Alexandria represented opportunity and education for some, nearly a quarter of the city's residents were held in slavery. The free black population was subjected to increasingly restrictive laws passed by the Virginia General Assembly, and as the 19th century progressed, sectional stresses threatened the nation.

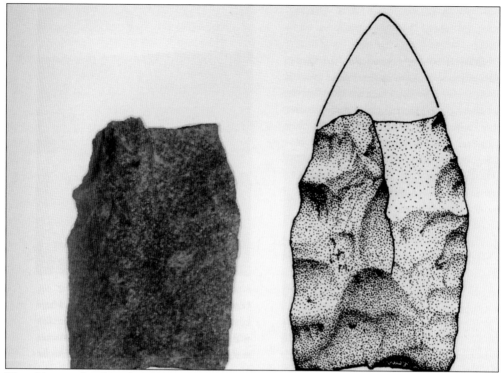

The oldest artifact found in Alexandria is a 13,000-year-old Clovis spear point recovered in 2007. During the Paleo-Indian period, from 13,000 BC to 10,000 BC, small bands of Native Americans lived in seasonal camps. They hunted in local woodlands and fished the rivers and streams. This point was made from local quartzite.

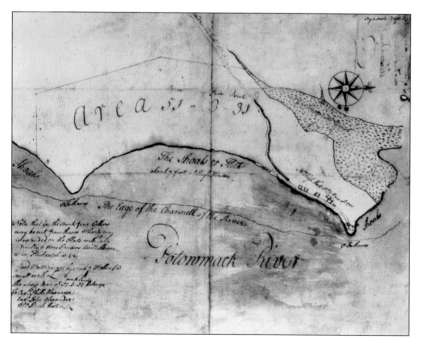

The sole warehouse on the waterfront in the early days was joined by about 12 more in the next 150 years.

Philip Alexander Married to Sarah Ashton
Jane Alexander daughter of Philip & Sarah
Born July the 1st ———————————— 1696
Elizabeth Alexander Born Sept. 5th ——— 1698
Sarah Alexander Born May 31st ——————— 1700
Philip Alexander Born July 22d ————— 1704
Annie Clifton Born Sept. 5th ————————— 1706
Burdett Clifton Born June 29th ———————— 1708

Philip Alexander Married to
Sarah Hooe Novbr. 11th ———————————— 1726
Frances Alexander daughter of Philip
& Sarah Born Oct.r 5th ———————————— 1728
Jane Alexander Born January 12th ———— 1730
Elizabeth Alexander Born December 23d 1731
Sarah Alexander Born September 30th 1733
John Alexander Born the 15th of Nov. — 1738
Philip Alexander Born May 31st ———— 1742
William Alexander Born March 3d 1744
Robert Alexander Born August 1st 1746
Capt. P Alexander father of the above
above Children Obit July the 19th ——— 1753
Sarah Alexander his wife departed
this life August 14th ————————

John Alexander immigrated to Virginia around 1653 and patented thousands of acres of land. His talents as a surveyor, justice of the peace, sheriff, and militia captain contributed greatly to the development of the region, and the city was named for him. His descendants also played a major role in Virginia's growth, with births, marriages, and deaths in the family Bible going back to the 1600s.

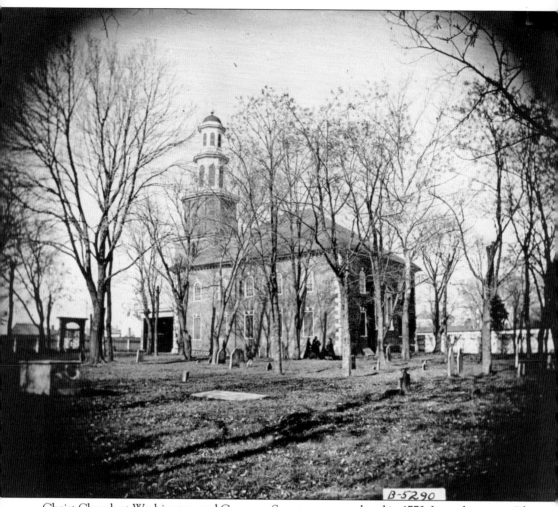

B-5290

Christ Church at Washington and Cameron Streets was completed in 1773. It was known as "the church in the woods" because it was several blocks beyond the town limits. George Washington and Robert E. Lee attended services here.

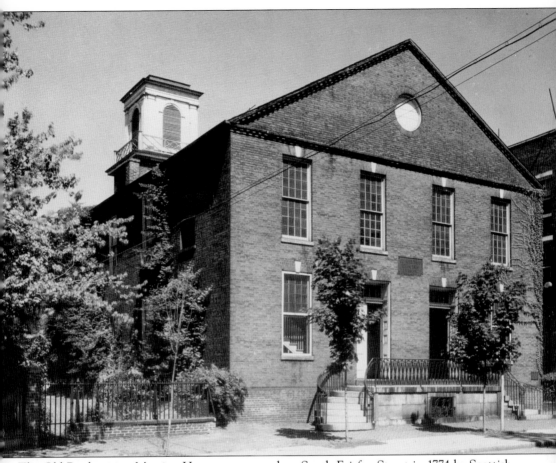

The Old Presbyterian Meeting House was erected on South Fairfax Street in 1774 by Scottish merchants who had been forced to worship secretly in their homes as "dissenters" from the official religion, the Church of England.

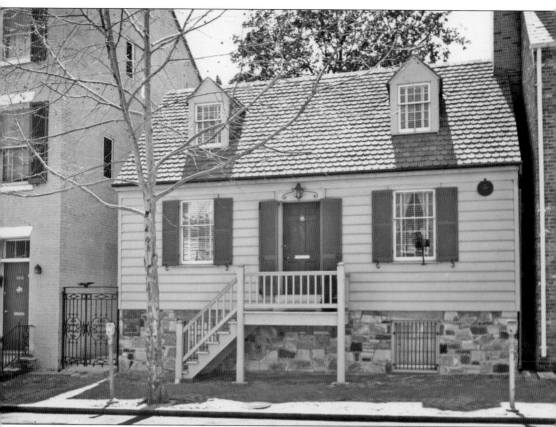

George Washington purchased a lot in Alexandria in 1763, building a structure on the site in 1769. After years of neglect, it was torn down in 1855. In 1960, Gov. Richard Barrett Lowe and his wife, Virginia, built this home on the site, basing its design on eyewitness descriptions of the original.

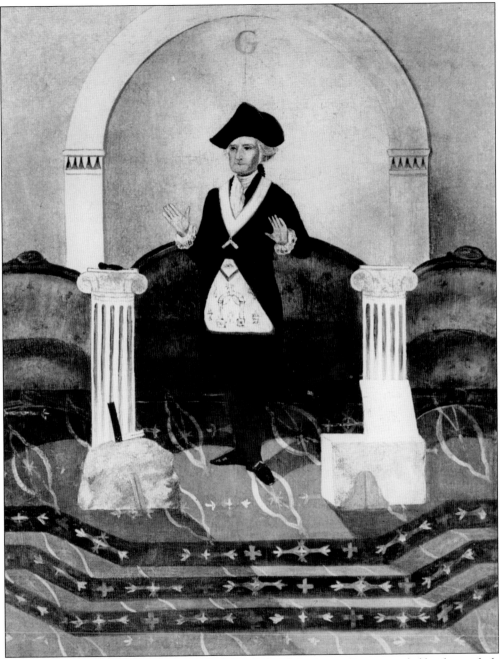

This oil on canvas painting of George Washington in Masonic regalia surrounded by the symbols of Freemasonry is from about 1840.

This calendar coin, dated 1809, was found in the Quaker Burying Ground, upon which the Queen Street Library was built in 1939. A thorough archaeological excavation took place in the early 1990s, and gravestones were removed to the Woodlawn Friends Meetinghouse Cemetery in Fort Belvoir, Virginia.

Each colony developed its own paper and coin currency. The paper notes were often quite decorative and depicted characteristics specific to that colony.

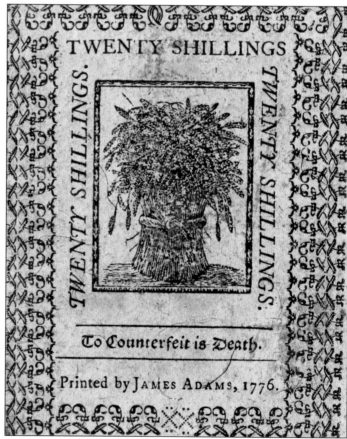

Elisha Cullen Dick, M.D. (1762–1825), mayor of Alexandria, was an influential member of the Society of Friends, also known as Quakers. Dr. Dick was the attending physician at George Washington's death.

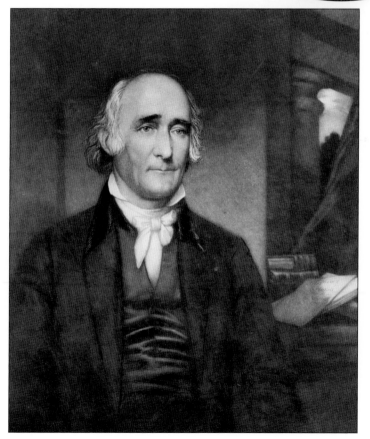

The Quaker teacher Benjamin Hallowell (1799–1877) provided leadership in education, reform, and science. Hallowell founded the Alexandria Lyceum, the Alexandria Waterworks, Maryland Agricultural College (now the University of Maryland), Haverford College, and Swarthmore College.

The Virginia Journal and Alexandria Advertiser began in February 1784 and ended in July 1789. The four-page weekly newspaper was published at the printing office on the corner of Fairfax and Princess Streets.

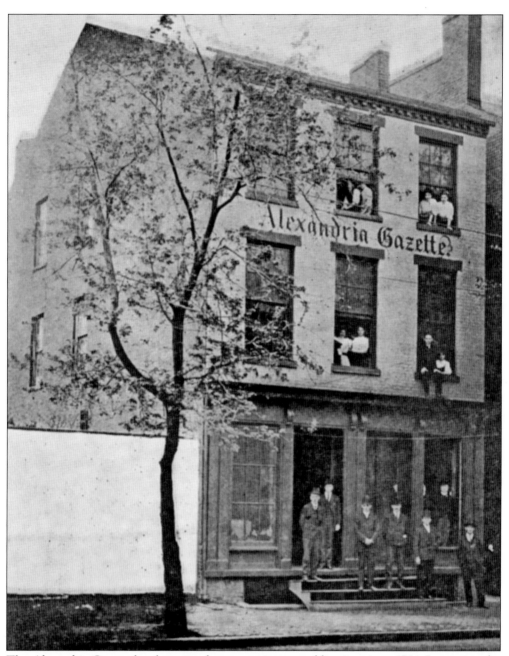

The *Alexandria Gazette* has been in almost continuous publication since 1784. It remains the paper of record for Northern Virginia. Its primary coverage includes business concerns, politics, and legal announcements. The newspaper was shut down during the Civil War after its offices were wrecked by angry Union soldiers.

The legend of the female stranger originated in September 1816 when a ship arrived from the West Indies bearing a well-dressed and sophisticated couple. The gentleman demanded the best accommodations for his ailing wife but refused to give his name. They were shown to Gadsby's Tavern, which was known then as City Tavern. A doctor and nurses were summoned immediately and sworn to secrecy, and the woman died a few days later.

The bereft husband left Alexandria immediately after making burial arrangements for his young wife. The female stranger was buried in St. Paul's Cemetery. One theory suggests that she was Theodosia Burr Alston, the wife of the governor of South Carolina and the daughter of Aaron Burr.

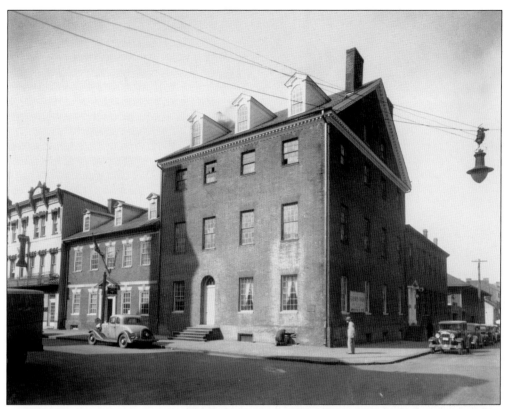

Gadsby's Tavern Museum is on the 100 block of North Royal Street. The museum comprises two buildings: the 1785 tavern and the 1792 City Hotel. For many years, the tavern was the center of Alexandria's social and political life. Over the course of its history, many famous Americans have dined and stayed here. In the 20th century, much of the outstanding interior woodwork was taken to the Metropolitan Museum of Art in New York City for display.

John Carlyle, one of the original Alexandria Trustees, built his impressive home on the east side of the 100 block of North Fairfax Street. The property sloped down to the riverfront, where Carlyle had the docks befitting a prosperous merchant. The property became a part of a hotel and became rundown over time. Numerous ghost stories are associated with the property, which is now a museum.

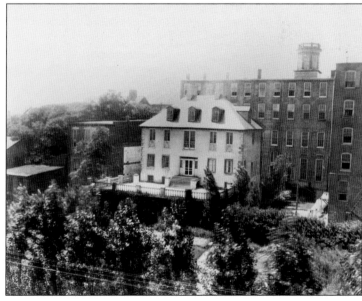

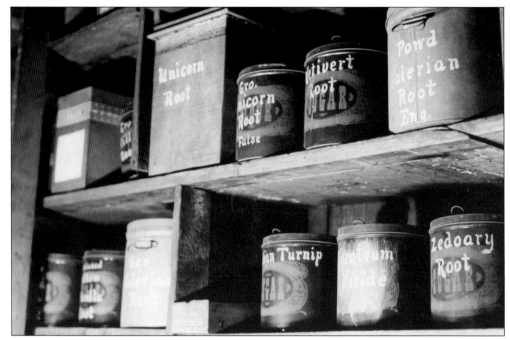

The Stabler-Leadbeater Apothecary was a family enterprise founded in 1792 and in business until 1933. It combined retailing, wholesaling, and manufacturing. Famous customers included Martha Washington, Nelly Custis, and Robert E. Lee.

The Stabler-Leadbeater Apothecary Museum has a collection of herbal botanicals, hand-blown glass, and medical equipment. It also has archival materials including journals, letters and diaries, prescription and formula books, ledgers, orders, and invoices.

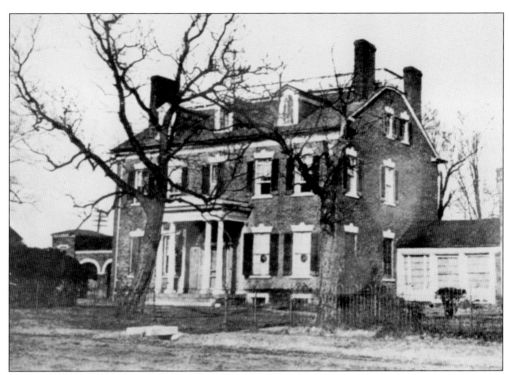

Constructed by John Potts around 1800, Colross became one of the grandest and most fashionable addresses in the city. Owned for many years by the descendants of George Mason, the property was seized by federal authorities during the Civil War. Local lumber and coal businessman William A. Smoot owned the property for some time. In 1927, a tornado ripped through the property, making it uninhabitable. The structure was eventually dismantled and moved brick by brick to Princeton, New Jersey, where it was reconstructed.

The lyceum movement that swept across America in the antebellum period reached Alexandria in the early 1830s. Committed to bringing education and cultural enlightenment to the public, the local Lyceum Company featured lectures and programs. Local Quaker schoolmaster Benjamin Hallowell was a leader in this endeavor, and in 1839, a new Lyceum hall opened on South Washington and Prince Streets. It was a private home and office building before the city bought it and made it a museum.

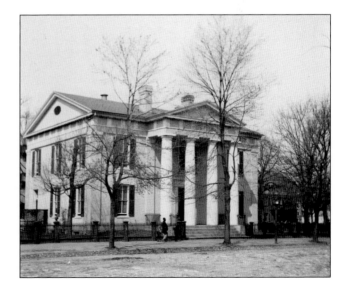

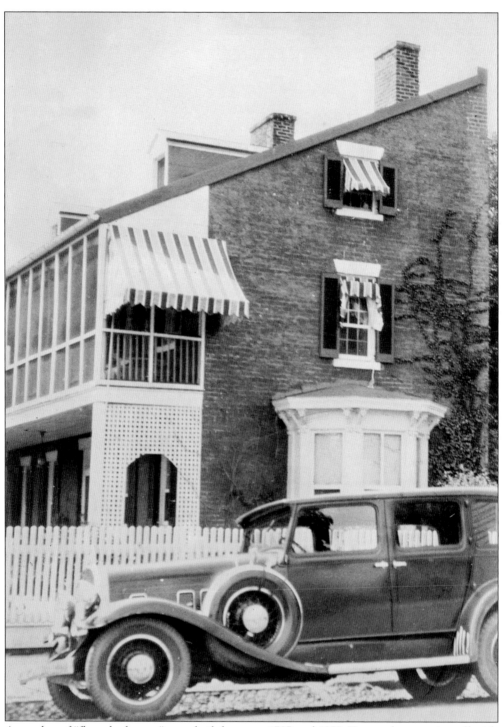

A number of "flounder houses" were built between 1787 and 1877. Two or three stories tall with a sloped roof, the odd shape is said to resemble the "eyeless side of the flounder fish." The houses could be erected quickly, and the windowless taller side reduced a resident's tax payments on glass used for windows.

Two

ALEXANDRIA AND THE CIVIL WAR

On the morning of May 24, 1861, the Union army crossed the Potomac by bridge and boat and seized much of Northern Virginia. Alexandria was quickly occupied, largely without incident. Local Confederate forces fled southwards or surrendered. The riverside community became a center of the Federal war effort for the next four years.

Entrepreneurs of various stripes came to the area in search of their fortune. Photographers offered young soldiers away from home for the first time an opportunity to create a memento for their families. Store owners and shopkeepers, sutlers and bar owners, and card sharks and prostitutes did a thriving business. Alexandria was transformed into a place where good people feared to go out.

Strong and capable workers were required to construct infirmaries and repair railroads. They transferred supplies by wagon and hauled food and fodder. Many had been enslaved in Virginia and nearby states. They sought freedom behind Union lines. Alexandria was both a refuge and a social laboratory. The Society of Friends and Presbyterians sent teachers and nurses to establish schools.

Robert E. Lee's home, Arlington House, overlooking Washington, DC, was seized by the federal government, and much of the estate was turned into a cemetery. A large and quite successful freedmen's village was established on the grounds. At war's end, Union soldiers marched through Alexandria on their way to Washington for the victory parade. Many residents had been devastated by the war but many more had gained freedom and opportunity. Americans who had only read about George Washington were now able to visit the first president's estate and Alexandrian sites associated with the "Father of Our Country." Many tried oysters for the first time. They returned to their homes with a deeper appreciation for the size and diversity of the country. Many Northerners remained in Alexandria and created new lives by the Potomac.

There has been a bridge at this site since as early as 1809. On the morning of May 24, 1861, Union cavalry and infantry crossed the Potomac over the Long Bridge and marched south to seize Alexandria. That bridge was not far from today's Fourteenth Street Bridge. This view of the Long Bridge looks north from the Virginia shore.

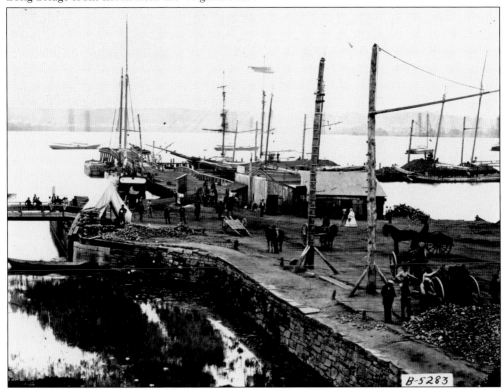

The Alexandria Canal was begun in 1831 for the purpose of drawing trade from the Georgetown waterfront. It joined the Chesapeake and Ohio Canal, a waterway for coal, grain, and other materials from the Potomac Valley. During the Federal occupation, the canal was closed and drained. Though it reopened after the war, it was abandoned by 1887. The city was left with an enormous debt to the canal company.

On the morning of May 24, 1861, the proprietor of the Marshall House, James Jackson, shot and killed Col. Elmer Ellsworth. Ellsworth, a protégé of Pres. Abraham Lincoln, and a comrade were descending from the roof after having torn down a Confederate flag large enough to be seen from Washington, DC. Seconds after Jackson killed Ellsworth, Jackson was dispatched by Ellsworth's brother-in-arms. This event provided both North and South with their first martyrs. This postcard dates from many years after the war, which is a testimony to the iconic nature of both the event and the place.

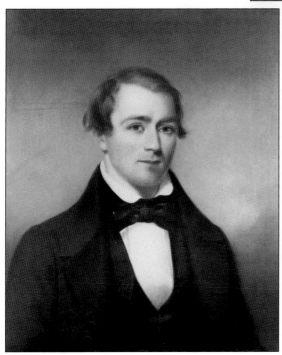

Alexandria native Lewis McKenzie was a very successful businessman and entrepreneur. Before the Civil War, he was one of the founders of the Alexandria, Loudoun & Hampshire Railroad. During the Federal occupation, McKenzie was elected as the Unionist mayor and served from 1861 until 1863, when he was elected to the US Congress. In the postwar years, McKenzie served in the city and state governments. An avowed Unionist, he was unpopular with many of the city's pro-Confederate citizens. He was appointed postmaster in 1878. When he died in 1895, he was respected but not very well liked by many in the community.

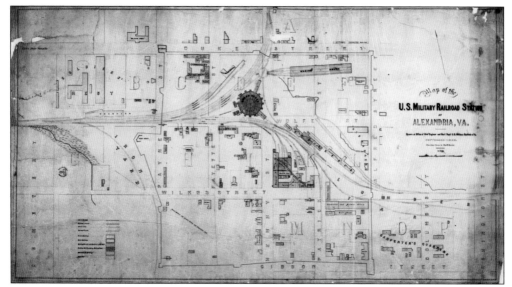

The United States Military Railroad (USMRR) complex was a warren of activity. This map shows the 12-block enclosure from which a steady stream of materials was sent out to the Army of the Potomac. After combat, train cars returned with the sick and wounded.

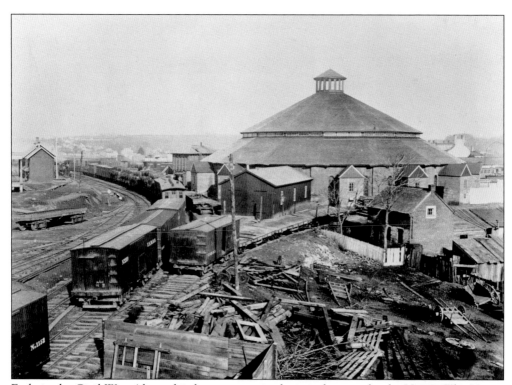

Early in the Civil War, Alexandria became a major logistical center for the Union. The Union army took over the Orange and Alexandria Railroad in order to supply troops in the field. This view of the USMRR roundhouse looks northwest.

Gen. Herman Haupt, head of the USMRR, inspects the construction at the railroad yard. The USMRR complex and the city docks were protected by wooden stockades, and access was restricted. The USMRR employed thousands of former slaves who had fled the Tidewater and Piedmont regions of Virginia for freedom behind Union lines. Alexandria's encampments, bakeries, hospitals, and businesses offered African Americans employment and a chance for a new and better life.

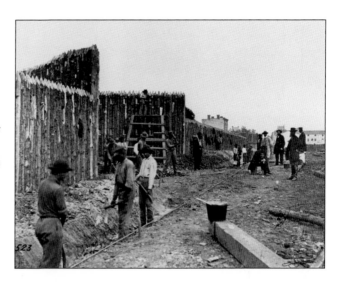

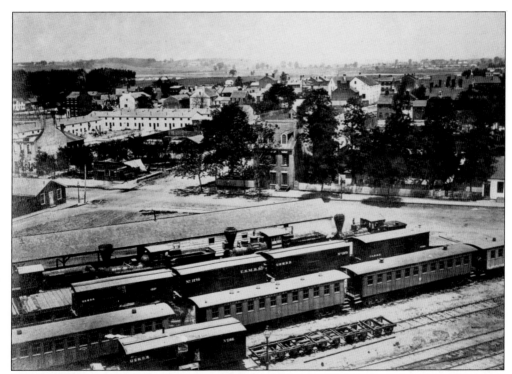

The USMRR roundhouse made for an excellent crow's nest. This image, taken from the cupola of the building, looks north along Fayette Street. Duke Street, which runs from the docks into the Piedmont, cuts through the middle of the picture. The extensive white buildings in the upper left are the "contraband barracks," which served as temporary housing for thousands of people on the road to freedom. Note the USMRR markings on the cars in the foreground.

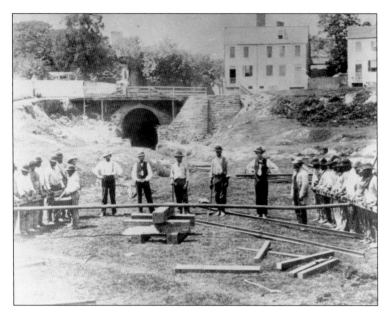

A group of African American railroad workers posed for the camera while they straightened rails in front of the Wilkes Street tunnel. This area, now a park, allowed substantial workspace for repairing sections of track. Many African Americans established residence to the north (right) and along the waterfront (behind the viewer).

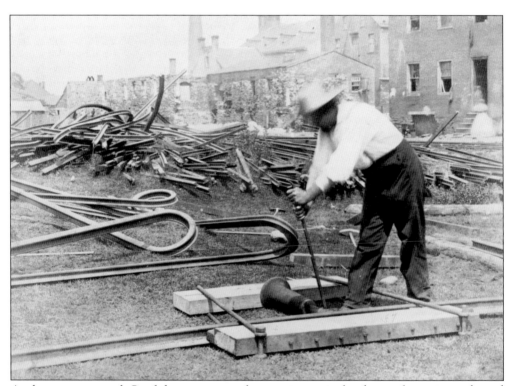

As the war progressed, Confederate partisans became increasingly adept at destroying rails, and the United States Military Railroad became equally adept at straightening bent and damaged track. A USMRR employee uses this device to straighten a rail. This segment of track is near the foot of Wilkes Street close to the waterfront.

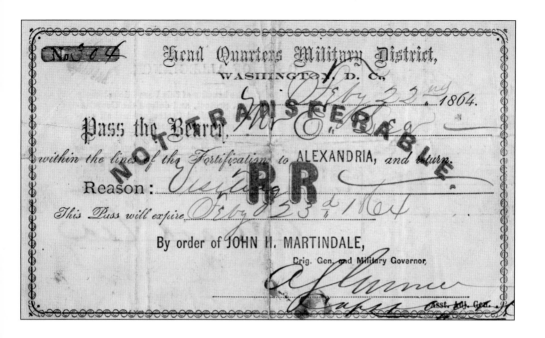

No. 64

Head Quarters Military District,
WASHINGTON, D. C.,

Feby 22nd 1864.

Pass the Bearer, Mr. E. Lea

within the lines of the Fortifications to ALEXANDRIA, and return.

Reason: Sundry

This Pass will expire Feby 23d 1864

By order of JOHN H. MARTINDALE,
Brig. Gen. and Military Governor,

Asst. Adj. Gen.

Civilian movement was restricted after the Union army occupied Alexandria and parts of Fairfax County. Residents and visitors wanting to enter or leave the city had to apply for passes, and only loyal citizens were allowed passes. The back of the document was printed with a loyalty oath, which the bearer had to sign. The pass also required a physical description of its bearer. Many Alexandrians left for points south rather than live under what some referred to as a "military dictatorship."

Age 49

Height 5 - 10

Complexion

Hair

Eyes

OATH OF ALLEGIANCE.

In availing myself of the benefits of this Pass I do solemnly affirm that I will support, protect, and defend the Constitution and Government of the United States against all enemies, whether domestic or foreign; that I will bear true faith, allegiance, and loyalty to the same, any ordinance, resolution, or law of any State convention or legislature to the contrary notwithstanding; that I will not give aid, comfort, or information to its enemies; and further, that I do this with a full determination, pledge, and purpose, without any mental reservation or evasion whatsoever:

Edward Lea

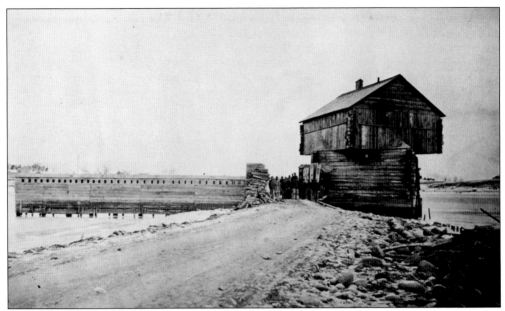

The Union army relied on Alexandria as a major supply base, so the city was heavily fortified during the war. This image, taken from the Fairfax shore on the south side of Hunting Creek, shows the blockhouse and the heavy walls that protected access to the Accotink Turnpike Bridge. The large black mass on the horizon to the distant right was the Smallpox Hospital. The disease could spread quickly among thousands of young men crammed in camps. The hospital building stood long after the war and had an evil repute.

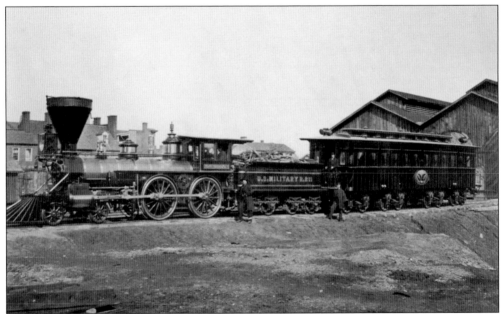

The USMRR yard constructed a car for the personal use of the president. Many hands, black and white, contributed to the building of this finely appointed conveyance. Tragically, Lincoln used it only once, for the transportation of his remains to Springfield, Illinois, for burial.

The Alexandria Athenaeum was originally constructed in 1851–1852 as the Bank of the Old Dominion. During the Civil War, it was taken over by the Federal army and became the chief commissary office for the city. The Athenaeum stands at 201 Prince Street on a block that still looks much the same.

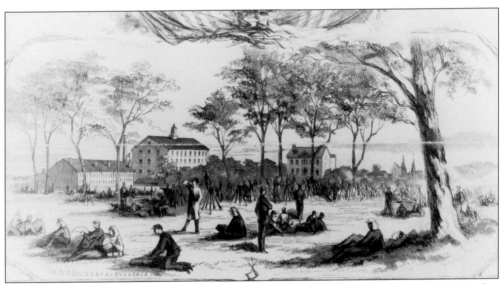

The 71st Regiment of New York was among the Union forces mobilized to occupy Alexandria after the taking of Fort Sumter, South Carolina. This lithograph shows the New Yorkers encamped under a grove of trees in rural Alexandria. The building with the cupola was the Cotton Factory.

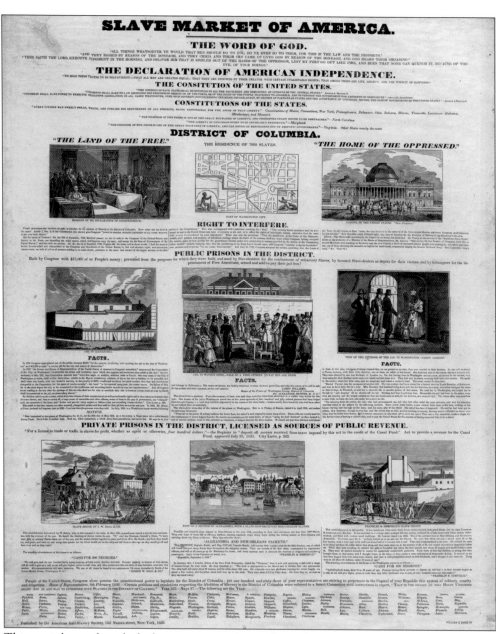

This anti-slavery broadside features scenes from Alexandria and Washington, DC. Line two features a slave jail in Alexandria, a slave jail in Washington, and Fanny Jackson and her children. Line three includes a coffle of slaves leaving the slave house of J.W. Neal & Co, the Alexandria waterfront loading human cargo, and a slave trading company, Franklin & Armfield.

By the early 1800s, Alexandria was a center for slave trading. Franklin & Armfield, George Kephart, and eventually Price Birch were all dealers who operated out of the city. Many thousands of enslaved people were taken from the property on Duke Street and either marched in coffles overland or packed into ships for the journey to New Orleans or to places like Forks of the Road in Natchez, Mississippi.

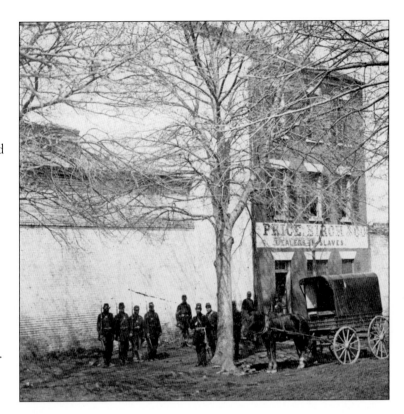

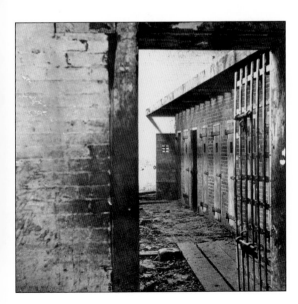

This house at 1315 Duke Street was a private residence in 1812, but by the mid-1820s, it had become the "Negro Jail"—the place where slaves were held until they were sold. The Franklin & Armfield Company operated the "slave pen" at this location, selling and transporting thousands to the Deep South. By the time of the Civil War, the business was owned by Messrs. Price and Birch. A company of Confederate cavalry encamped there when Union troops entered the city. Caught unawares, they were held as captives in the slave-pen-turned-military-prison. The house is now the Freedom House Museum and is operated by the Northern Virginia Urban League.

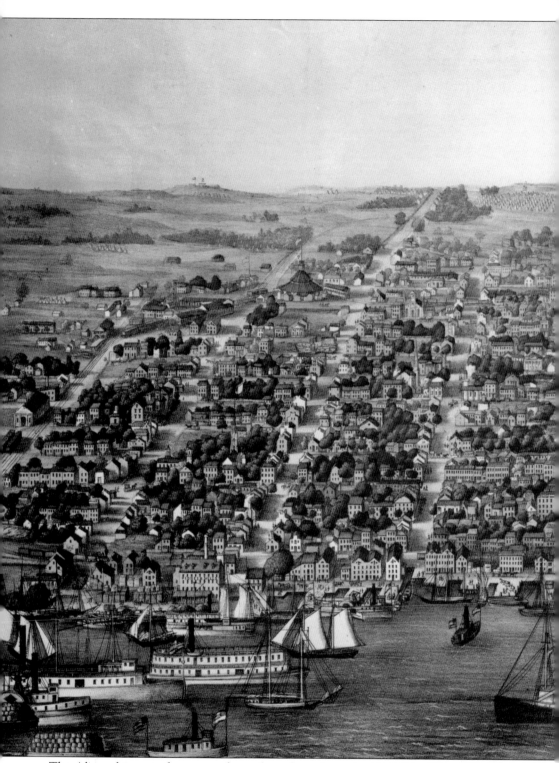

The Alexandria waterfront was a busy place throughout the Civil War. This 1863 lithograph paints an accurate picture of the city's geography and buildings. As an art form, bird's-eye or aerial

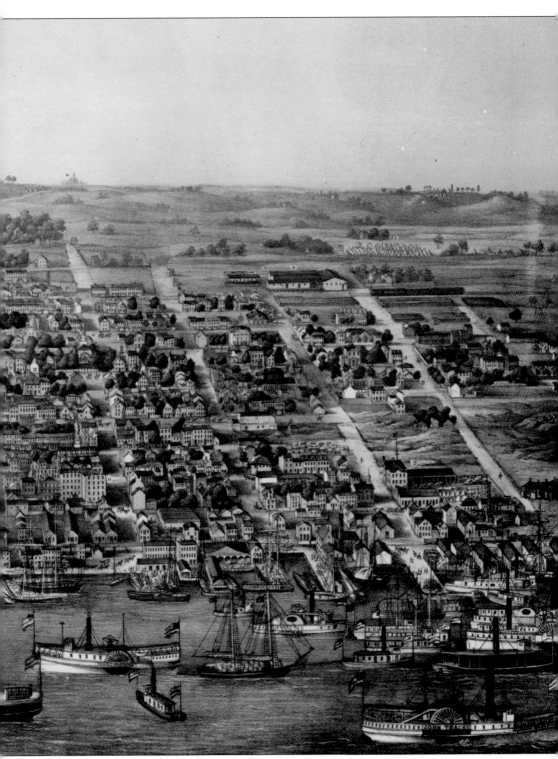

views became very popular during the mid-1800s.

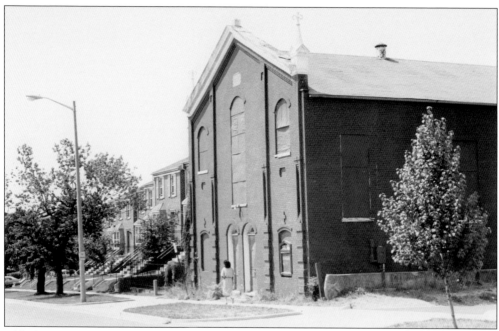

Alfred Street Baptist Church dates back to 1803, but the property was not purchased until 1842, and the first building was constructed in 1855. The first African American minister assumed the pulpit four years later. In 1861, the church was taken over by Union forces and used as a hospital and receiving station. A larger structure was built between 1881 and 1884. The church continues to fill a vital role in the community.

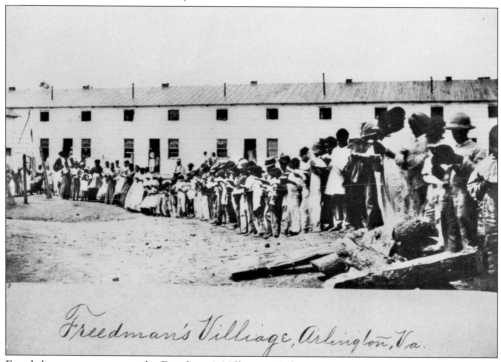

Freedman's Villiage, Arlington, Va.

Freed slaves congregate at the Freedman's Village in Arlington.

Three

FROM RECONSTRUCTION TO WORLD WAR II

When the Civil War ended in 1865, Alexandria and the rest of the nation struggled to come to terms with what had been lost and what had been gained. Many had died, and others were crippled emotionally or physically. Alexandria worked to improve the lot of its citizenry. The city and surroundings were still overwhelmingly rural, but the availability of telephones and electricity increased dramatically in the late 1800s. Industry only modestly succeeded at a local level, but there were advances. Alexandrians created an infirmary and then a hospital in the early 1900s. There were theaters, cultural events, picnic grounds, and restaurants aplenty. By law, nearly all institutions and diversions were racially segregated. A significant number of taxpaying and law-abiding Alexandrians were not allowed the full benefits of citizenship.

When the United States became involved in World War I, Alexandrians volunteered for service with equal enthusiasm, but their military experience was anything but equal. White Americans who did not want to serve with "colored" men were satisfied when African American units were assigned to serve with the French military.

At the time, "separate but equal" was the law of the land across the south and not unusual in the north. Alexandria's moment of attention came in 1939, when the struggle for equality was reported on by papers across the country. A brilliant young attorney, Samuel W. Tucker, was determined to bring equal justice to the city. His efforts to ensure equal access at Alexandria Library had mixed results. While the case, covered extensively in the African American press, was resolved in August 1939, it was overshadowed by Hitler's invasion of Poland. When Tucker's service as a major in the US Army ended, he became the lead attorney for the National Association for the Advancement of Colored Persons (NAACP) in a number of lawsuits against the Commonwealth.

The war years brought thousands of new residents. Many worked for the government or the military. Close to Washington, DC, as well as extensive farmlands, it was an ideal location for new housing and office developments. This trend of expansion continued for decades.

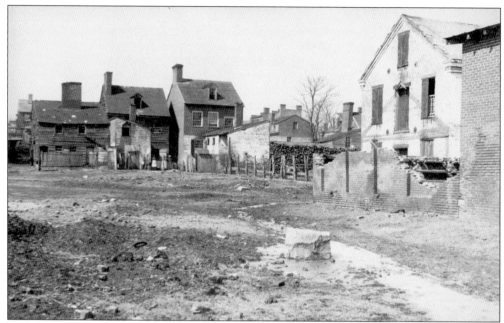

In the years following the Civil War, Alexandria remained somewhat rural and impoverished. In this typical view, declining wood and brick structures sit alongside an unpaved and undisclosed byway. The large stone in the foreground might be a mounting stone or detritus.

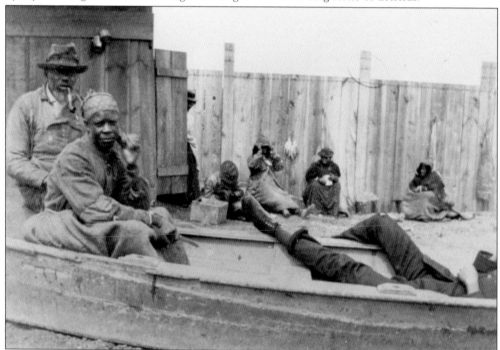

African American men and women were employed in various capacities along Alexandria's docks and wharves. As carters, chandlers, cooks, and sorters, they contributed significantly to the local economy. In this picture, taken after the Civil War, workers take a break from their labors to have a meal.

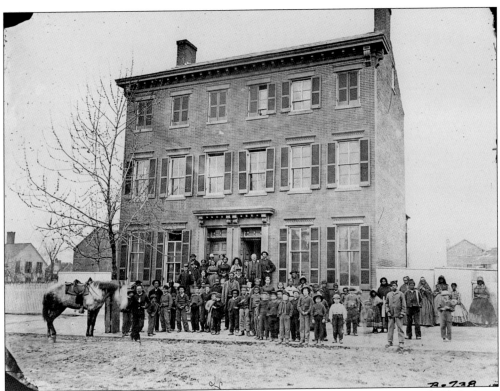

This group was most likely associated with a Freedman's Bureau school at 321–323 South Washington Street. The gathering of men and women, adults and children, military and civilian, well-dressed and shabby, and black and white paints an accurate picture of postwar changes in Alexandria. The double house was built in 1859, a wedding gift from wealthy china and glass merchant Robert H. Miller to his son, Elisha.

The Old Virginia House, later renamed the Hotel Jackson, was built before 1878 on the 1400 block of King Street. In its early days, the hotel catered to carters and drovers bringing stock and produce into town from the Piedmont. Over time, the hotel came to service African American travelers. In 1927, a tornado that ripped through town destroyed the facade of the building. The property was soon torn down and was eventually replaced by a Coca-Cola bottling plant.

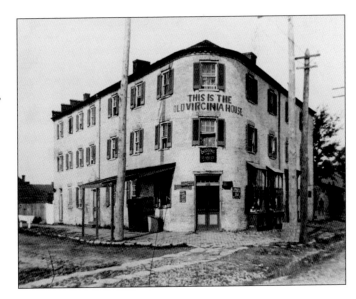

The People's Advocate.

J. W. CROMWELL, Editor. PRINCIPLES—NOT MEN; BUT MEN AS THE REPRESENTATIVES OF PRINCIPLES. T. B. PINN, Publisher and Business Manager.

VOL. I. R. D. BEXLEY, General Agent. ALEXANDRIA, VA., SATURDAY, MAY 6, 1876. TERMS: $1.50 PER YEAR. NO. 4.

The Great Exhibition.

A Bird's-Eye View of the Grounds, Etc., at Philadelphia.

Illustrations of Notable Buildings with Descriptions Thereof.

THE CENTENNIAL EXHIBITION BUILDINGS,

FAIRMOUNT PARK, PHILADELPHIA.

MAIN EXHIBITION BUILDING.

THE FIRST PRAYER IN CONGRESS.

Philadelphia Hotel Customs.

MACHINERY HALL.

A General View.

HORTICULTURAL HALL.

The American Flag.

The Billiard Tournament.

Visitors to Philadelphia.

Resorts Near Philadelphia.

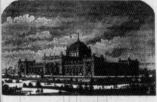

ART GALLERY.

In the Way of Locomotion.

What Australia Shows.

System of Awards.

Accommodations at Philadelphia.

The People's Advocate was an African American newspaper published in Alexandria from April 22, 1876, to July 31, 1886. Its motto was "Principles—Not Men; But Men as the Representatives of Principles."

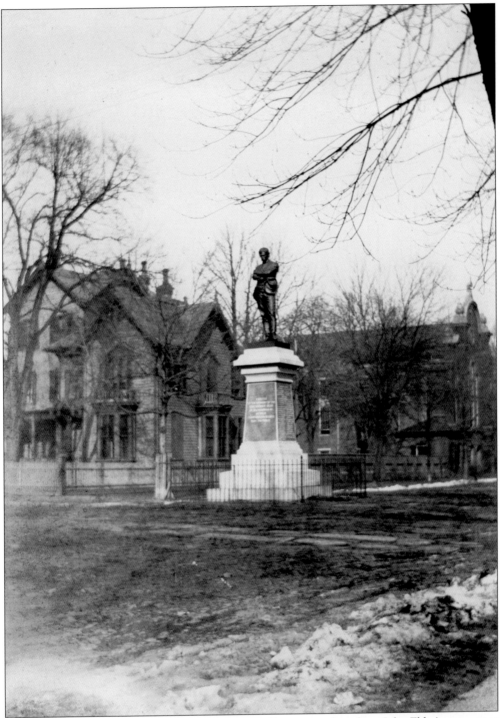

At the intersection of Prince and South Washington Streets stands sculptor John Elder's monument to Confederate veterans. The statue, called *Appomattox*, was one of the most popular figures in postwar southern monuments. A relatively quiet intersection in 1889, the year of its dedication, the statue now stands in the midst of several lanes of commuter traffic.

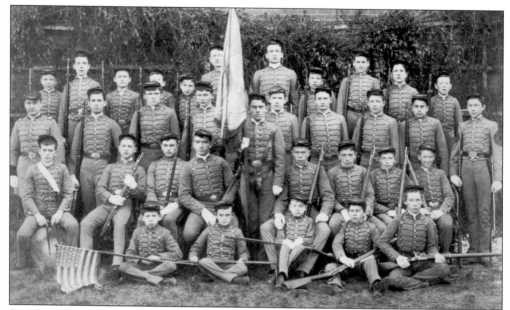

St. John's Academy educated 1,800 young men from 1833 until it closed in 1895. Many students and graduates served in the Mexican-American War and in the Confederate army. In some cases, several generations of young men from a family attended the academy. Students came from all over Virginia and from many other states, and some were immigrants whose families eventually settled in Northern Virginia.

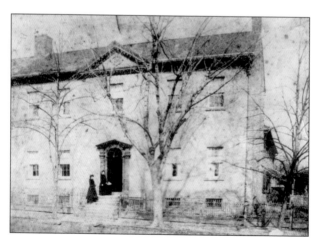

The all-brick Federal house at 607 Oronoco Street was constructed in 1795 by John Potts and was later occupied by Ann Hill Lee and her children. The Marquis de Lafayette visited the family during his 1824 tour of the United States. In later years, Robert E. Lee lived here before enrolling at the US Military Academy at West Point, and the house was occupied by Archibald MacLeish, poet, writer, and librarian of congress. This picture is from the 1870s or 1880s.

St. John's Academy, at Prince and Columbus Streets, featured this distinctive glass cupola.

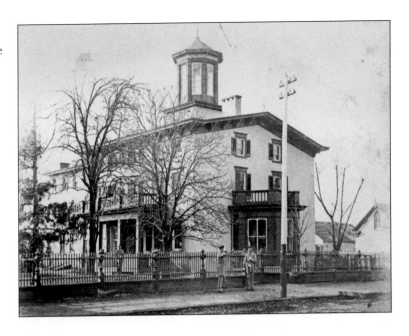

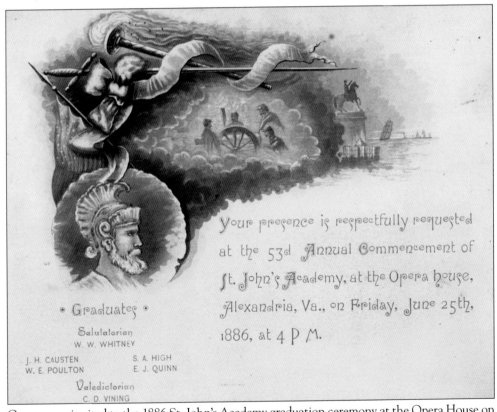

Your presence is respectfully requested at the 53d Annual Commencement of St. John's Academy, at the Opera House, Alexandria, Va., on Friday, June 25th, 1886, at 4 P.M.

• Graduates •

Salutatorian
W. W. WHITNEY

J. H. CAUSTEN S. A. HIGH
W. E. POULTON E. J. QUINN

Valedictorian
C. D. VINING

Guests were invited to the 1886 St. John's Academy graduation ceremony at the Opera House on Friday, June 25, at 4:00 p.m. The six graduates were W.W. Whitney (salutatorian), J.H. Causten, S.A. High, W.E. Poulton, E.J. Quinn, and C.D. Vining (valedictorian).

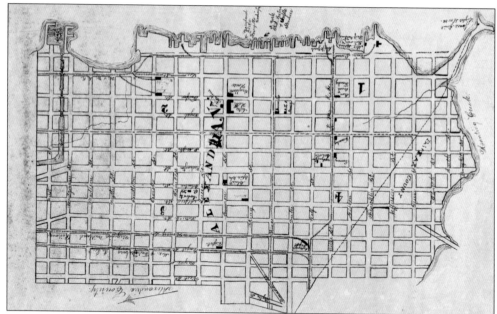

This map of Alexandria was signed by "Thomas S. Lannon (Age 15), December 1884, Washington School." Lannon was one of five children whose parents immigrated to Alexandria and belonged to St. Mary's Church. He became a bookkeeper for his father's grocery store and later moved to Washington, DC, where he worked for a beef company. He and his wife, Kate, had three daughters: Dorothy, Katherine, and Margaret.

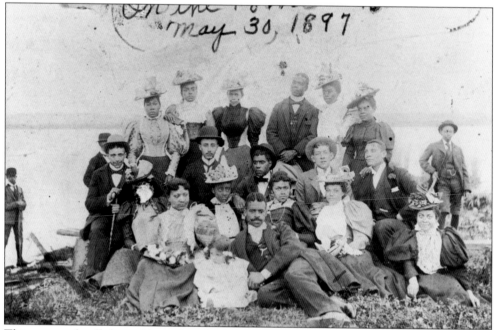

This group of well-dressed but relaxed friends enjoys a leisurely outing on May 30, 1897. A handwritten note states that the location was at Jones Point, but it is more likely that the location was Bromilaw Point on the Hunting Creek estuary. Bromilaw Point was where African American families promenaded.

Hume Springs in northern Alexandria became something of a local tourist destination. The mineral spring was named for the socially prominent Hume family, which was involved in local politics and government.

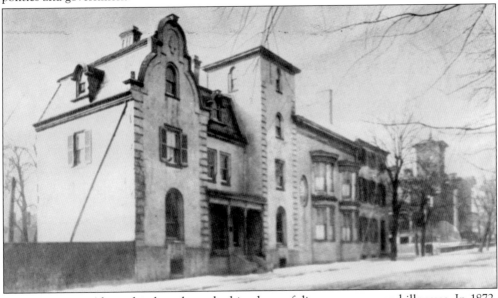

As a port town, Alexandria has always had its share of diseases, agues, and illnesses. In 1872, Julia Johns, the daughter of an Episcopal bishop and a lady of great determination, founded the Alexandria Infirmary on Duke Street. This property on Wolfe Street was also used for a number of years until the first Alexandria Hospital opened in 1894.

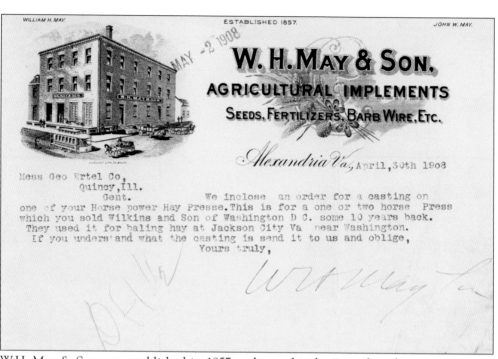

WILLIAM H. MAY. ESTABLISHED 1857. JOHN W. MAY.

W.H. MAY & SON,

AGRICULTURAL IMPLEMENTS

SEEDS, FERTILIZERS, BARB WIRE, ETC.

Alexandria Va., April, 30th 1908

Mess Geo Ertel Co,
 Quincy, Ill.
 Gent. We inclose an order for a casting on
one of your Horse power Hay Presse. This is for a one or two horse Press
which you sold Wilkins and Son of Washington D C. some 10 years back.
They used it for baling hay at Jackson City Va near Washington.
If you understand what the casting is send it to us and oblige,
 Yours truly,

W.H. May & Son was established in 1857 and stayed in business for a long time, in part because of the continued need for agricultural supplies like tools, seed, and fertilizers in semi-rural Alexandria.

The George R. Hill Company manufactured crackers, cakes, and cookies. It was organized in 1869 and succeeded the Jamieson Cracker Bakery, established in 1785. Seagoing vessels provisioned their crews with hardtack manufactured in Alexandria.

Will Keep on Hand During the Season ALL KINDS OF FRESH AND FRESH CUT FISH. Will Fill All Orders at Lowest Prices and Guarantee Fresh Stock.

Alexandria, Va., Apr 16, 1900

M. M. Hatcher

Bought of **J. MATTHEWS,**

GENERAL PRODUCE - FISH MERCHANT,

AND WHOLESALE DEALER IN Pork, Potatoes, Butter, Eggs, Poultry, Green and Dried Fruits and Country Produce Generally. FINE TABLE BUTTER A SPECIALTY.

TERMS STRICTLY CASH. No. 113 NORTH FAIRFAX STREET.

To 200 G. Hy 35 To 00

Let your orders come will do the best for can for you

PROSPECTS.

J. Matthews General Produce and Fish Merchant Wholesalers could count on steady income to keep up with the expenses of running a retail business around 1900.

STATEMENT.

Mr C. P. Dean

IN ACCOUNT WITH

ROBERT PORTNER BREWING COMPANY

TIVOLI BREWERY

TIVOLI TRADE MARK ALEXANDRIA VA.

Alexandria, Va., July 1st 1912

Billheads in the early 1900s often featured lavish detail about the enterprise. This illustration of the Robert Portner Brewing Company showcases prosperity and order, not beer and ale.

49

These die-cut trade cards were distributed by the Keystone Watch Case Company to watchmakers to help them promote Keystone products. Most Keystone cards showed cases being used in unusual ways—as skate wheels or as the main body of a comet. In this example, a grasshopper is reminded of the passage of time as it looks at a clock in a play on the fable of the grasshopper and the ant.

The Emerson Pump and Valve Company was known for innovative mechanical devices used extensively on railroad construction. This advertisement showcases modern and streamlined products that were marketed as "the best device of its kind in existence." In fact, the company's hydrants, valves, and valve boxes were shipped worldwide and won international design awards.

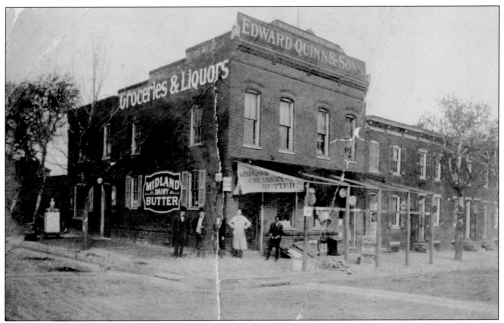

The Quinn Grocery, at 527–529 Oronoco Street, was started by Irish-born Edward Quinn, who came to America in 1859 and settled in Alexandria in 1862. After working on the US Military Railroad for four years, he opened the grocery, which specialized in home delivery. His stock of staples and fancy groceries was fortified with wines, liquors, and his own Oronoco brand of whiskey, aged seven years for mellowness. Quinn died in 1908, leaving several of his sons to carry on the business. Although the building changed hands over the years, it continued as a grocery until the second half of the 20th century, when it was a florist, a flooring store, and finally Old Towne School for Dogs.

Joseph Koffler emigrated from Manchester, England, and served in the US Army during World War I. He purchased the Oronoco Street grocery store from Quinn and was in business for about 30 years. Koffler's summer birthday parties, of which he was the honoree, became a neighborhood tradition. Koffler would give out celebratory refreshments to neighborhood children dressed in their Sunday best. The grocery eventually closed in the face of competition from supermarkets. Koffler died in 1965.

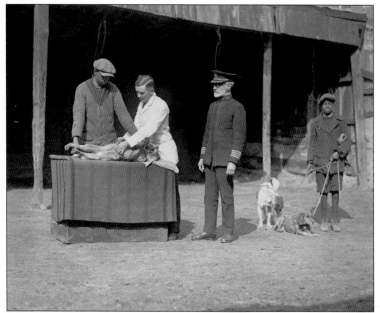

In February 1925, several rabid dogs bit local residents. The city adopted a drastic ordinance to mandate canine vaccination. Residents were instructed to bring their dogs to the city stables at 110 North Lee Street for the procedure. City veterinarian Dr. James J. Garvey (in white coat) prepares a dog for the operation while city health officer Dr. L.E. Foulks (in uniform) looks on.

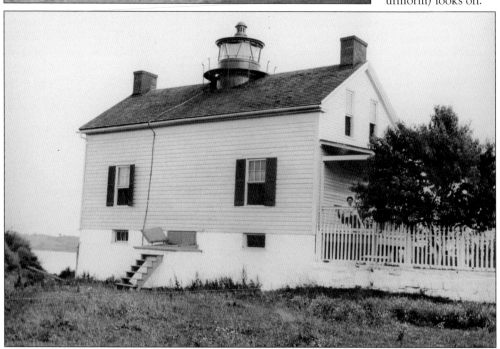

Once a sandy point thrusting out into the Potomac above Great Hunting Creek, Jones Point has changed shape over the years as generations of Alexandrians have filled in and added land all around it. Since 1856, the Jones Point Lighthouse has stood to guide shipping up the often shallow Potomac River to safe harbor. By 1926, the lighthouse was replaced with an electric light, and the lighthouse became increasingly derelict. Eventually, the Mount Vernon Chapter of the Nation Society of the Daughters of the American Revolution (NSDAR) acquired it and, with the help of the National Park Service, restored the house and property. The original cornerstone for the District of Columbia is now on the property as well.

This aerial view looking north towards Reagan National Airport and Washington, DC, shows Potomac Yard in its heyday. Opened in 1906 and serving several railroads, the yard became one of busiest rail centers on the east coast, processing thousands of cars a day. Workers established neighborhoods nearby, but after World War II, the railroad began a slow decline, and the yard closed by the 1980s. The land is currently under redevelopment.

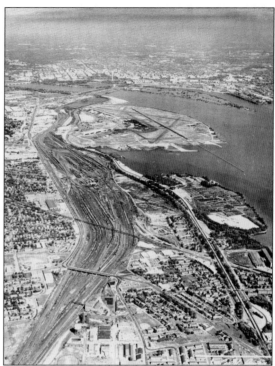

In 1871, a fire destroyed the original city hall, which long housed the Masonic Museum. Rescued items were eventually placed at the George Washington Masonic Memorial. Adolph Cluss, a prominent architect, developed the design for this structure, built by 1873. This view from around 1890 from the corner of Royal and Cameron Streets shows the north facade of the building.

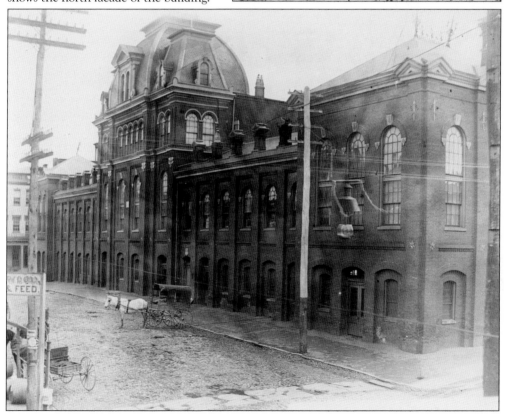

Dilapidated market stalls like these along Market Alley towards Royal Street were common in the early 1900s. Though rundown and somewhat worse for wear, Alexandria was still open for business.

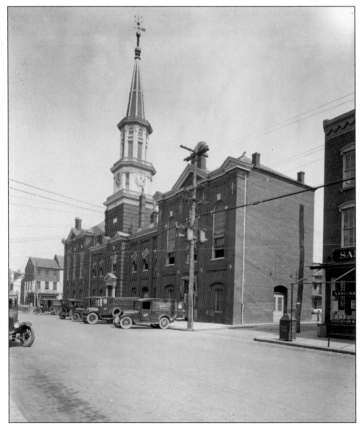

The Alexandria Market House, a part of Alexandria City Hall, occupied half of the north 100 block of Royal Street. Market Alley, in the foreground, provided access to the interior shops and stalls. The central market operated in one form or another until destroyed in the 1960s by urban renewal and the growth of supermarkets. This view looks northeast along Royal Street, with Gadsby's Tavern just out of view to the left. (Courtesy of the Library of Congress.)

The great snowstorm of 1922 is known for causing the tragic collapse of the Knickerbocker Theatre in Washington, DC. Across the river in Alexandria, 150 men worked to clear snow from streets and fireplugs. The drifts prevented firemen from responding to a fire at St. Paul's Church.

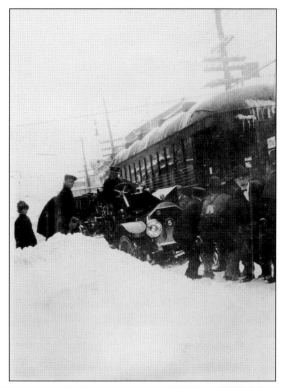

Most likely taken around 1900, this view looks south down Royal Street from near the corner of Prince Street, an upper-crust area in Alexandria. The spire of St. Mary's Catholic Church is in the distance. The congregation was created in 1795, and it has been at this location since 1810. The large low building on the left is the city armory.

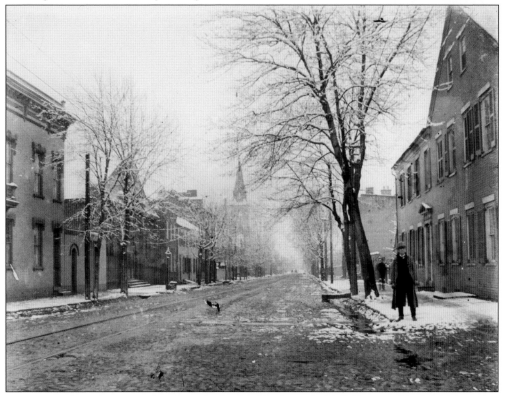

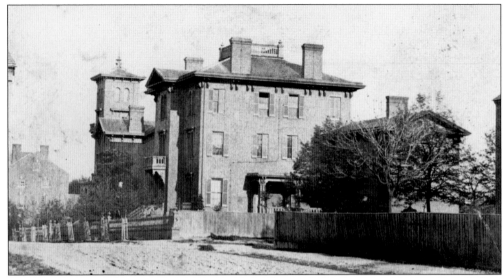

The house at 510 Wolfe Street was built in 1854 by Francis L. Smith, personal attorney to Robert E. Lee. During the Civil War, the Union army used the property as a 100-bed hospital; the Smith family later reclaimed their home in 1865. Maggie Smith, the last of Francis L. Smith's children, died in 1926.

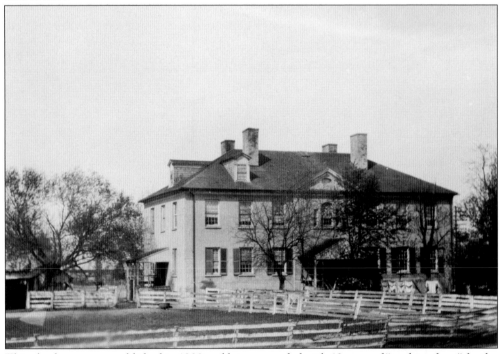

This almshouse was established in 1800 and later expanded with 10 acres of "working farm" for the benefit of its residents. In 1927, the City of Alexandria joined with the Fairfax, Prince William, Culpepper, and Fauquier Counties to build a district almshouse, and the remaining 13 residents of Alexandria's almshouse were transported by train to their new home in Manassas. Joshua Sherwood, almshouse superintendent for 18 years, accompanied his charges. This old building was sold in August 1928 to Robert and Hattie Frame for $18,000.

Lannon's Opera House, on the second floor of 500–508 King Street, was built in 1884 and designed to seat 1,600 people. The first floor housed a restaurant and game room. The entertainment venue was the site of graduations, political meetings, charity bazaars, boxing matches, oratory, and professional theater performances. Lannon's name was associated with the property for many years after he died in 1886. It was leased to Louis Brill, who became the proprietor of Brill's Opera House Restaurant on the first floor, then J.W. Summer, and finally to John Marriott Hill. Hill, a printer by trade and a gambler by temperament, was a dedicated booster of Alexandria. He leased the building from 1887 through 1909, renovating the space at least once. When he died in 1916, the lease went to the Alexandria Amusement Company. It was demolished in 1969.

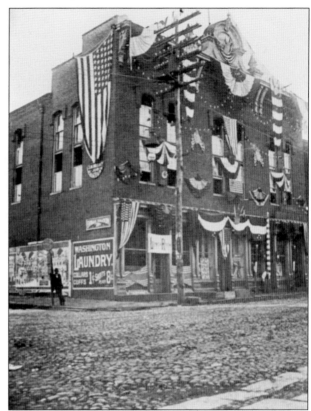

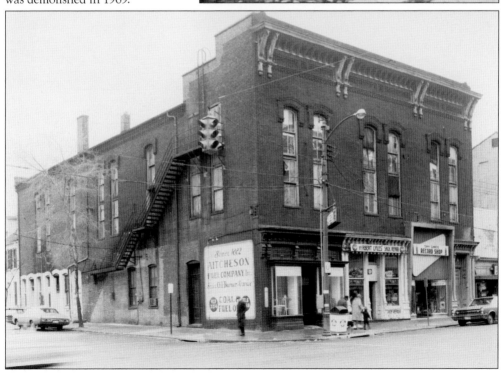

In August 1910, Alexandria hosted the 24th Annual Convention of Virginia Volunteer Firemen. The three-day convention drew hundreds of delegates and their families from across the commonwealth. Band concerts, parades, and contests of all sorts kept participants busy.

Henry James "Harry" Truax, shown at the 1899 George Washington birthday parade, was an aide to marshal Charles B. Paff. He was one of many men who directed participants and made sure the parade went smoothly. This *Washington Post* article from October 11, 1899, sums up the night: "To-night the streets were absolutely impassable. The private decorations were illuminated for the first time with electricity, and thousands of persons left their homes to gaze upon the inspiring sights."

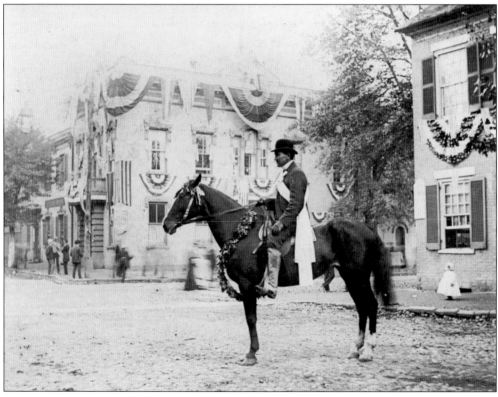

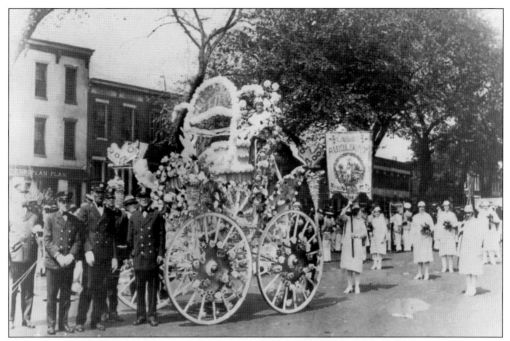

The city fire companies always turned out for a good parade. Here, Columbia Engine Company No. 4 turns out with a flower-bedecked pumper and its ladies' auxiliary in the late 1800s.

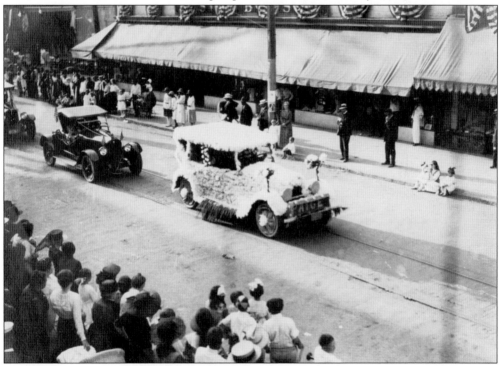

The 20th century brought many exciting changes to the city, but parades were a mainstay. Horse-drawn carriages may have been replaced by automobiles, but still no parade was complete without something covered in flowers.

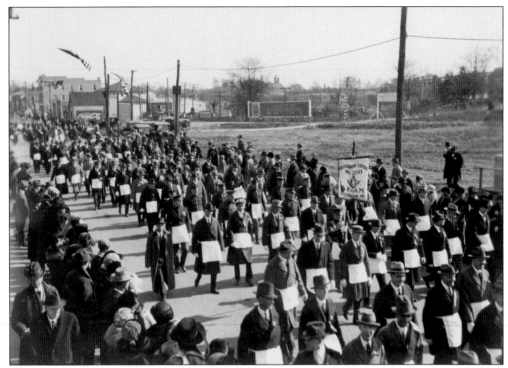

The City of Alexandria declared a public holiday for the cornerstone-laying ceremony on November 1, 1923. A crowd of over 15,000 people included Freemasons who had traveled from across the country to participate. In this photograph, a long procession of Masons makes its way to the memorial.

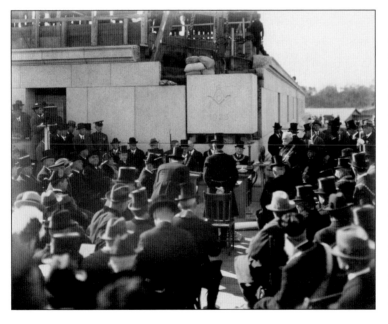

Construction on the George Washington Masonic Memorial began in 1922. The elaborate cornerstone-laying ceremony was almost cancelled because the cornerstone had been cut too small. Luckily, quick-working stonemasons fashioned a stone with the correct dimensions. President Coolidge and former president Taft attended the ceremony.

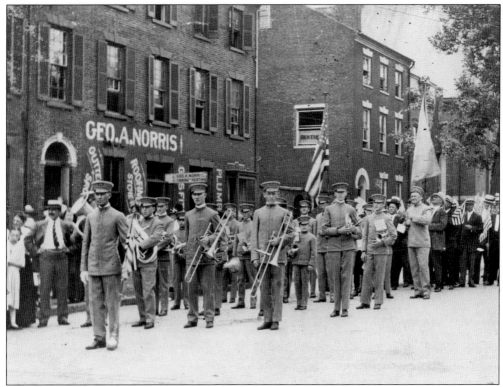

The Holy Name Band provided a send-off for the Alexandria Light Infantry, officially named Company G, 1st Regiment, Virginia Infantry, when it departed for Richmond to mobilize with other Virginia troops in 1916.

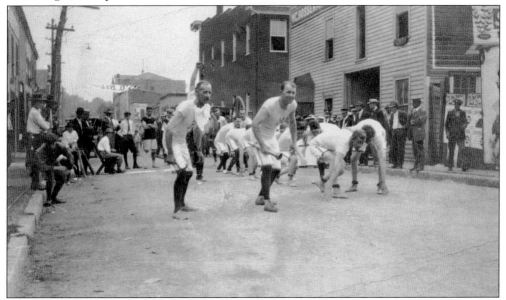

This photograph was most likely taken at the 24th Annual Convention of Volunteer Firemen of Virginia, held in Alexandria in August 1910. The closing events were a series of races, most won by the Harrisonburg Hose Company.

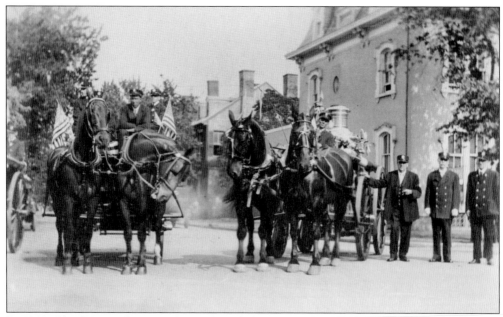

In 1918, Chief Kenneth W. Ogden gathered the Alexandria Fire Department for this group photograph. This is one of the last from the horse-and-wagon era. The photographer is standing on Washington Street in front of Christ Church looking east down Cameron Street. The vehicles, men, and horses are from the reserve company of the fire department.

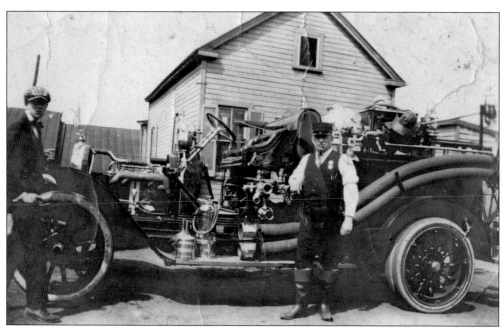

Kenneth Ogden was chief of the Alexandria Fire Department from February 1918 to May 1921. Under his leadership, the fire department evolved from using horse-drawn vehicles to using motorized equipment. Here the proud chief (in boots) shows off one of his new acquisitions.

This building at 515 North Washington Street has housed many businesses, including the Express Spark Plug Company in the 1920s.

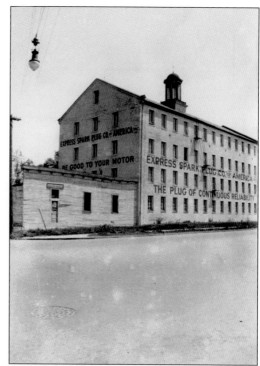

Many women were hired at the Express Spark Plug Company because their small hands were useful in the manufacturing of spark plugs.

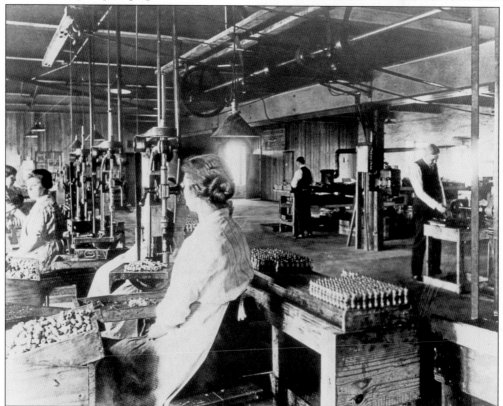

The Smoot tannery was established in the first quarter of the 19th century and remained in the family for three generations until an 1889 fire in the engine room spread to the tallow room and beyond. Nearly the entire facility was ruined. The loss was estimated at $50,000—more than $1 million today.

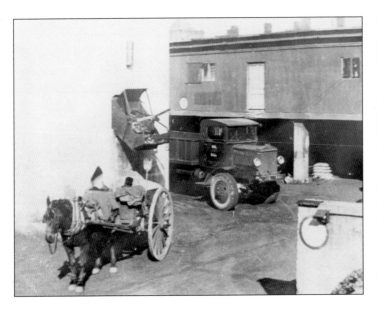

Thomas J. Fannon went into the coal and wood business in 1885 and eventually expanded into fuel oil and air-conditioning. Both the family and the business have a long history of public service. In this image, probably from the 1930s, a wagon pulls away from the coal chute as a newer truck rounds the corner to take on a larger load of coal. Wagons were still a useful delivery method for the city's many alleys and side streets.

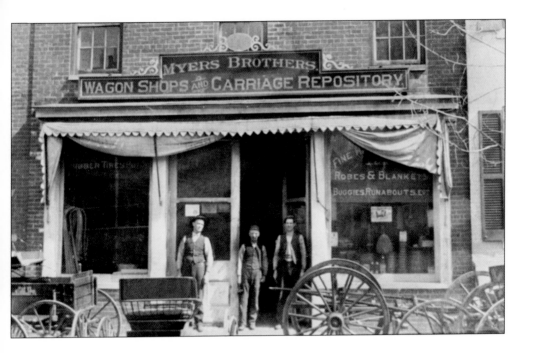

R.L. Myers was a savvy businessman who followed the transportation trends of his time. In 1895, he was proprietor of Chatham's Stables. In 1915, he sold automobiles, carriages, and was an implements dealer. By 1917, he had made the complete transition to auto dealer. In 1925, he sparked an imbroglio between the city manager, the mayor, and police court when he complained about vehicles being parked in front of his home.

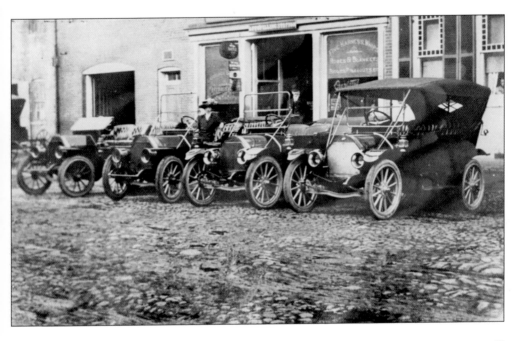

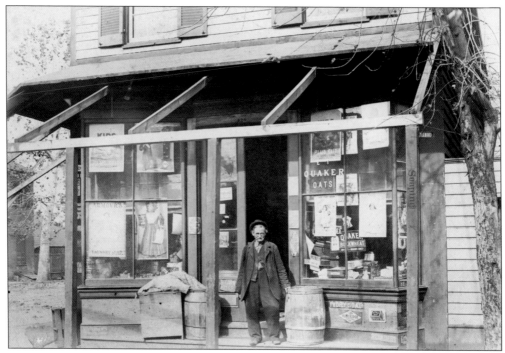

George Wells operated this family grocery at 429 Queen Street for many years. Until the 1950s and 1960s, most Alexandrians purchased their food and goods at small local groceries and markets. Dozens of markets were established all over town, with some specializing in meat or fish and most being urban general stores. These corner markets were the lifeblood of the Alexandria homemaker. By the 1950s, larger car-friendly supermarkets started putting these local markets out of business.

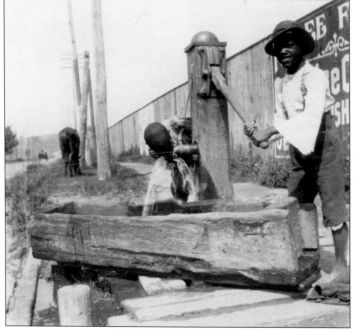

After 1819, Alexandrians could no longer dig private wells. Municipal health concerns led to the creation of deep public wells and pumps on street corners throughout town. This was the principal water source for most until the establishment of the Alexandria Water Company in 1851 or 1852.

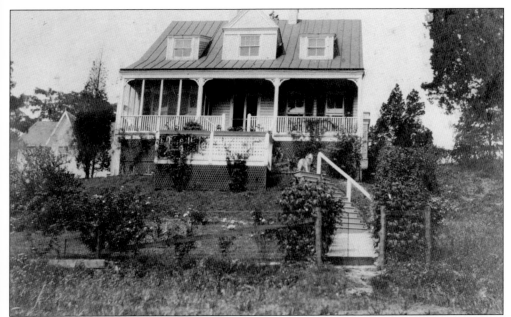

This home in Braddock Heights belonged to J. Johnston Green, the paying teller of the First National Bank of Alexandria. His daughter, Elizabeth Green Ogden, and son-in-law, Kenneth W. Ogden, occupied the upper level. In May 1911, a fire consumed the house, leaving little more than the outbuildings. Neighbors rushed to save what they could while volunteer firemen used chemical extinguishers to fight the fire. Some of Green's property, which was insured, was saved. None of Ogden's property, which was uninsured, could be saved. Ogden joined the Reliance Fire Company, eventually becoming fire chief and modernizing the fire department.

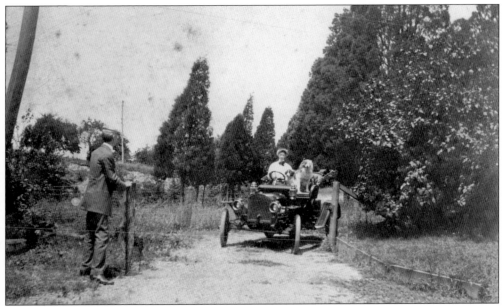

The Ogden family lived just outside the city in rural Braddock Heights.

In the days before air-conditioning, catching the breeze on the porch roof with friends was just another way to keep cool.

At the beginning of the 20th century, these women and their dog enjoyed an outing in an electric runabout. The vehicle was cheaper to own than an automobile. Electricity reached Alexandria in the 1880s, and by 1900, it was common in many households and farms.

Menokin, at right, was the home of Francis Lightfoot Lee, one of the signers of the Declaration of Independence.

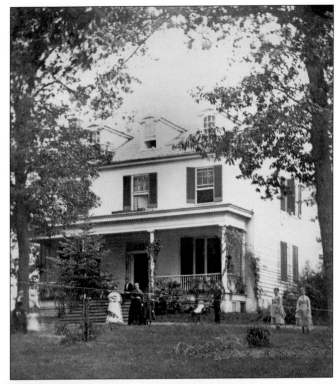

A group of well-dressed Alexandrians poses before a game of lawn tennis.

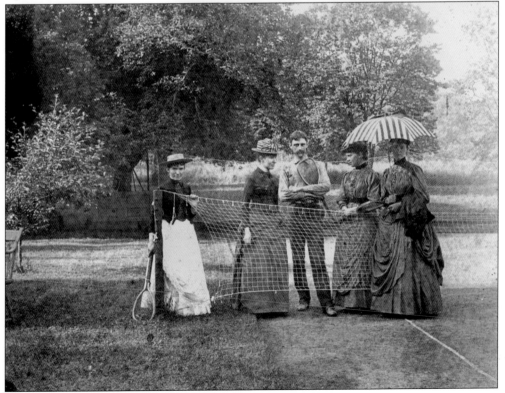

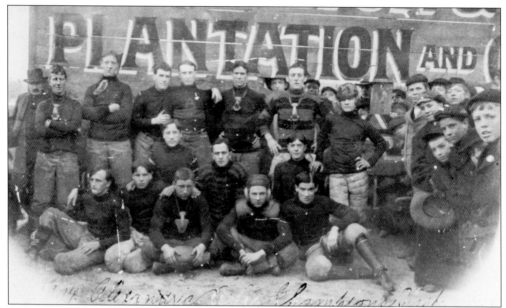

Before the era of professional sports teams, fans followed leagues and clubs. These rakish young men were the 1904 Alexandria Football League champions. Their equipment was comprised of padded pants, heavy boots, and leather helmets. Football and baseball clubs were very popular about town and had many fans, including the boys to the right.

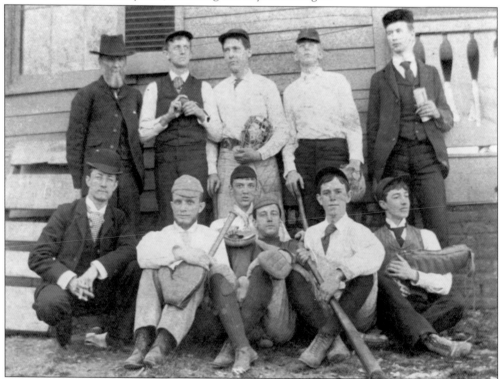

Alexandrians have always had a passion for sports. In the late 1800s, a time without national sporting events, small local groups like these were extremely popular.

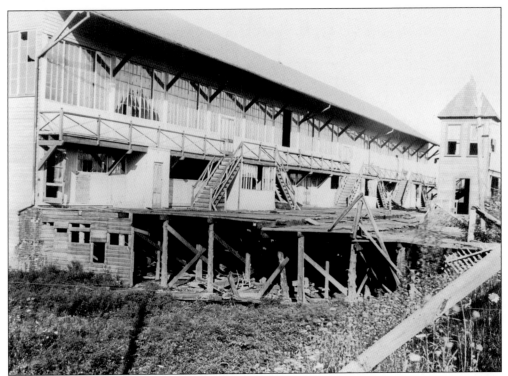

This racetrack was originally a half-mile track called the Gentlemen's Driving Park, but by 1890, antigambling laws had stifled the racing business. In 1894, John Marriott Hill and his brothers invested in improvements and doubled the track. Called St. Asaph Racetrack, it also included a "poolroom," or gambling facility. Furnished with a news ticker, telegraph, telephone, and blackboard, customers had access to races in Chicago, New York, and other racing towns. It became a target for antigambling forces and was closed in 1905. During the Spanish-American War, the property was used as a quartermaster's depot, and Hill once again found himself immersed in legal wrangling as he tried to recover damages visited on the property by the military. By 1916, fire had destroyed fences and stables and poor families lived under the grandstand. In April 1916, shortly after Hill's death, the rest of the grandstand burned.

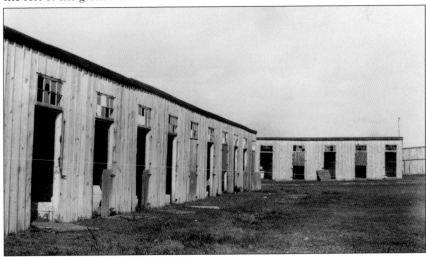

On April 9, 1898, the Italian training ship *Amerigo Vespucci* dropped anchor below Alexandria during a practice cruise. The immense vessel was difficult to navigate; to get it close to the docks, groups of men moved around the deck, shifting weight to ease passage across the shoals. The boat stayed anchored for 10 days before moving on to Philadelphia, and locals were invited aboard to tour the vessel. Special trains and boats even carried visitors from Washington, DC, to Alexandria.

Another boat circled the ship in the evening so the curious could view the exterior and take photographs. Returning the compliment, sailors came ashore to sightsee and buy souvenirs. The Italian officers were honored at a ball hosted by the Alexandria German Club at McBurney's Hall before they left. There were even rumors that the ship was sent to smuggle out the Spanish ambassador and his staff, which the crew scoffed at.

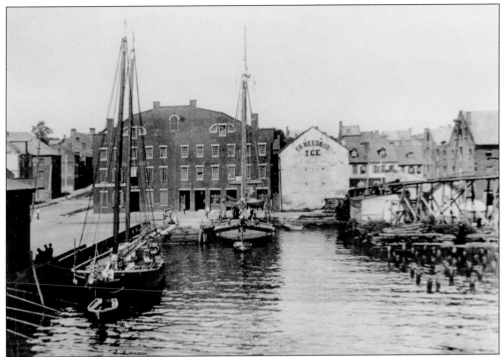

After the Civil War, Alexandria's waterfront remained fully involved in local trade and fishing in the bay. The F.R. Reed Ice Company operated on the water from 1873 to 1895, making ice largely for commercial use. The structure at the right is the conveyor belt used to haul large quantities of ice to waiting ships. The Torpedo Factory was later constructed in the large warehouse area to the left.

Riverboat service had been established in Alexandria before the Civil War, but Baltimore companies dominated river traffic during the late 1800s and early 1900s. The Norfolk & Washington Steamboat Company provided service until the early 1950s.

The Potomac River is an integral part of Alexandria's cultural landscape and many have lived or worked alongside the river. Before Prohibition, it was manipulated for entertainment purposes. Virginia banned alcohol sales before Prohibition became a national law, and since Maryland controlled the river up to the high-water mark on the Virginia shore, enterprising Marylanders set up their houseboats as taverns and brothels, a mere gangplank away from Virginia.

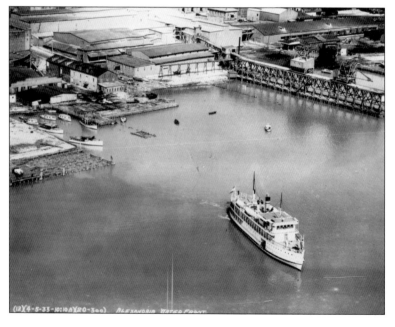

The south waterfront near Jones Point featured much industrial buildup in 1933, but little sign of people or activity. A number of houseboats cluster in the inlet at the left, but the vessel is most likely full of sightseers bound for Mount Vernon.

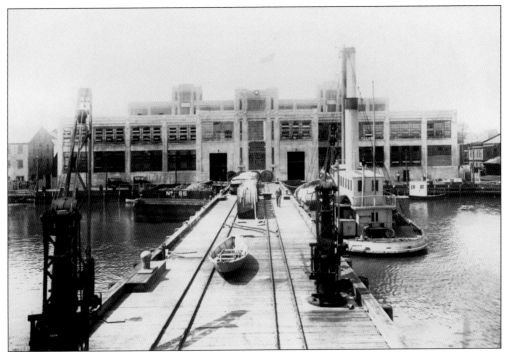

Construction of the Alexandria Torpedo Plant began in October 1918 and was completed two years later, just before this photograph was taken. By World War II, the plant was a necessary link in the US Navy's supply chain.

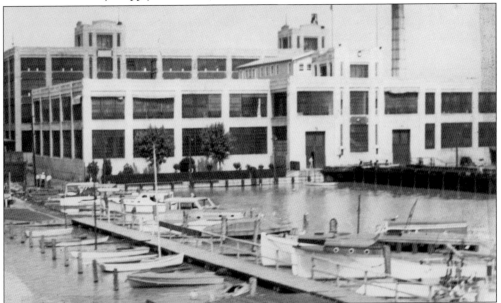

After World War II, the waterfront's popularity with boaters and fishermen grew, and the Torpedo Factory, at the foot of King Street, which had housed papers and documents seized from the German government in the closing days of the war, was empty. In 1973, Marian Van Landingham, the president of the Art League, proposed that the city purchase the building and develop it for studio space and an arts center. The Torpedo Factory Art Center opened on September 15, 1974.

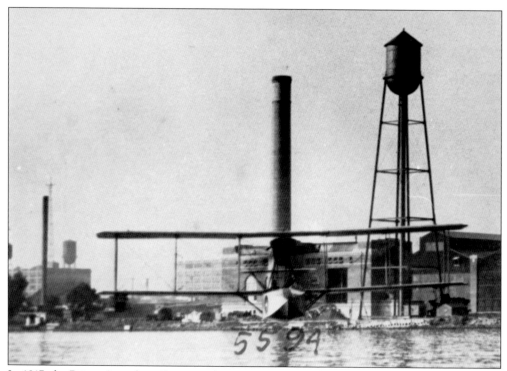

In 1917, the Briggs Aeroplane Company began operation in the former Portner Brewery building at St. Asaph and Pendleton Streets. The three leaders of the company were Blaine Elkins and Leonard Bonney, both pilots, and J.J. Rooney, an engineer and former employee of Curtiss Aeroplane and Motor Company. The Briggs Company, which was soon renamed Alexandria Aircraft Corporation, began building flying boats in the same style as the Curtiss design and sold them to the US Navy for use at Hampton Roads after testing in Alexandria. However, numerous larger operations were also building flying boats, and the planes built in Alexandria were ultimately found to be inferior to the Curtiss models. In the difficult market, the Alexandria Aircraft Corporation was dissolved by 1919.

World War II transformed Alexandria from a sleepy port town into an important part of US military efforts. Tugboats made daily trips to the naval station at Indian Point, Maryland, to transfer supplies and torpedoes. Though it was important and often dangerous work, this group of sailors took a moment to pose for a picture.

USS *Gunston Hall* was built at Jones Point. The cranes, scaffolding, and rails all had to be brought in and built on site before any shipbuilding could take place.

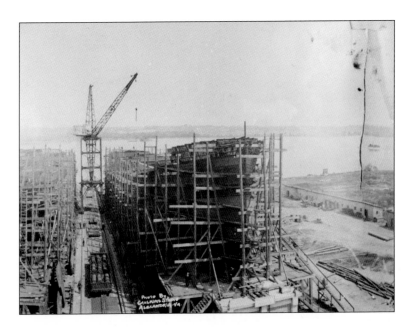

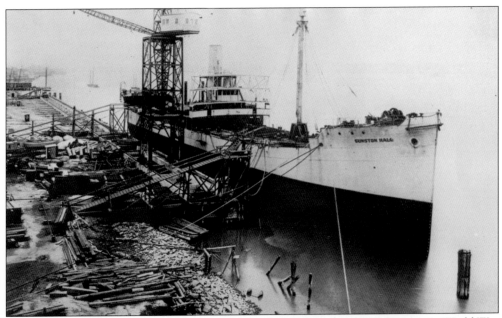

USS *Gunston Hall* was constructed in response to the need for merchant shipping in World War I. It was the first vessel launched by the Virginia Shipbuilding Corporation at Jones Point in 1919. The corporation was a subsidiary of Groton Ironworks. The shipyard was built from the ground up. No ships were launched before the Armistice was signed. After the war, the yard proved unprofitable and was closed.

In 1674, the Washington family came into possession of property along Little Hunting Creek in what would become Fairfax County. The property, known as Mount Vernon, passed through the hands of several family members until 1754, when it was owned by George Washington. Alexandria was the nearest town, and Washington visited it frequently. For more than 40 years, he made numerous changes to the original house and the land around it. Despite his work and innovation, Washington lost money on this property.

The great influx of Union soldiers into Alexandria during the war was a serious boost to the popularity of Mount Vernon. Tourism continued to flourish after the Civil War ended. The industry relied on excursion boats and trains to bring visitors to what was by then a remote location.

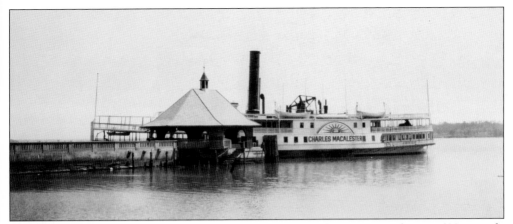

The ferry *Charles Macalester* was commissioned in 1889. With a capacity of over 1,600, it made one round-trip journey a day from the Seventh Street docks in Washington, DC, to Mount Vernon. The ferry, boasting an onboard café, was operated by the Mount Vernon and Marshall Hall Steamboat Company and named for the father of the regent of the Mount Vernon Ladies' Association, Lily Macalester Laughton.

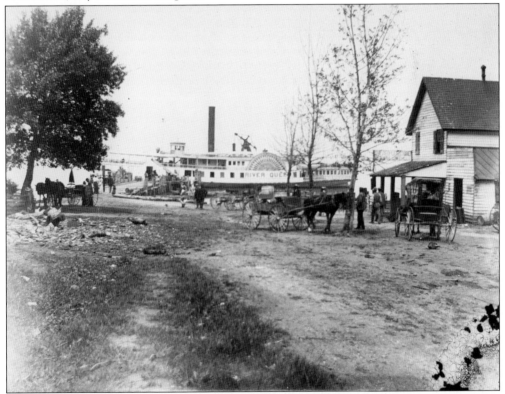

The steamboat *River Queen* had a long and eventful history. The Hampton Roads Conference met on it on February 3, 1865, in a last-ditch attempt by Confederate officials to negotiate a favorable peace. The *River Queen* transported numerous Federal generals, admirals, and politicians. In fact, Pres. Abraham Lincoln was aboard just two days before his assassination. The Mount Vernon and Marshall Hall Steamboat Company purchased the ship in 1893. In its last years, the *River Queen* was used primarily for African American passengers. It burned in 1911.

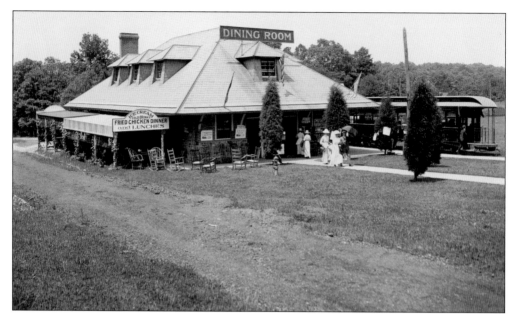

The Washington, Alexandria & Mount Vernon Railway began operation in 1892. Instantly popular, it was an inexpensive way to reach George Washington's home. The Mount Vernon Ladies' Association insisted on a "modest" terminal facility in keeping with the dignity of their site. The railway operated until 1923, when buses offered a less expensive means of transport. The current traffic circle in front of Mount Vernon is built on the old railroad right-of-way where trains turned around.

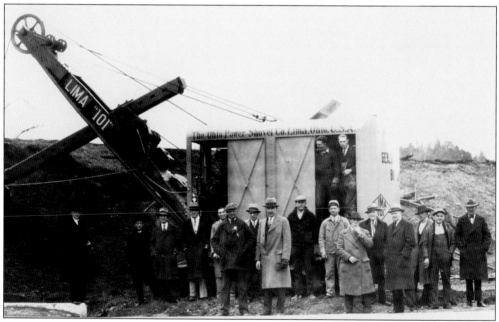

In 1930, the federal government began construction on the George Washington Memorial Parkway. The road, built as a memorial to the first president, linked his Mount Vernon estate to the Washington, DC. The parkway continues west to Great Falls, where Washington was instrumental in the first attempt to improve navigation on the upper Potomac River, the Patowmack Canal.

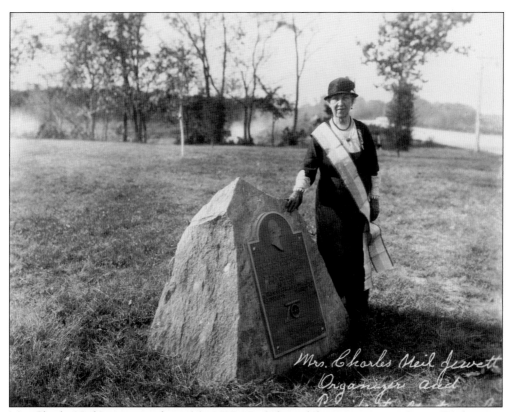

Mrs. Charles Neil Jewett, president of the NSDAR, dedicated this monument to George Washington just a mile north of Mount Vernon. The Potomac River and the mouth of Little Hunting Creek are in the background.

The George Washington Memorial Parkway is seen here in its early days, before too much new vegetation had been able to grow on its sides. The parkway is now a major commuter artery for Alexandria and Washington, DC.

This section of the George Washington Memorial Parkway is just north of Mount Vernon and south of Little Hunting Creek. The gently curving parkway, with views of river and woodlands, made a fitting entryway to Mount Vernon.

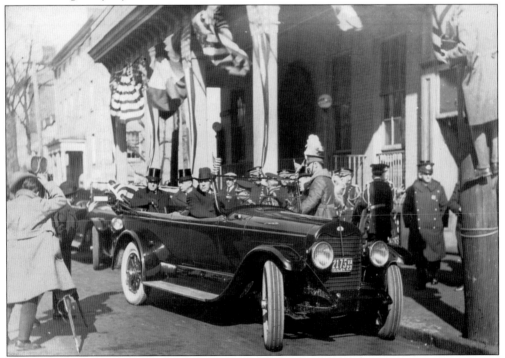

Vice Pres. Calvin Coolidge participated in Alexandria's George Washington Birthday Parade. Six months later, Pres. Warren G. Harding died in office and Coolidge became president.

Pres. William Howard Taft (left center) poses with Speaker of the House Joseph Gurney Cannon (center) and Virginia governor Claude A. Swanson (right center). Speaker Cannon was considered by many to be the most powerful man in the nation's capital. When this photograph was taken, the newly constructed House office building had just been named for him. In March 1910, Cannon suffered major political setbacks and left Congress.

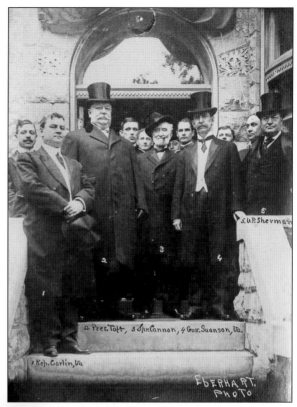

Pres. William Howard Taft is pictured here at a Masonic event in Alexandria. President Taft, known as a reformer and a trustbuster, was the only president to be appointed to the Supreme Court after leaving the White House.

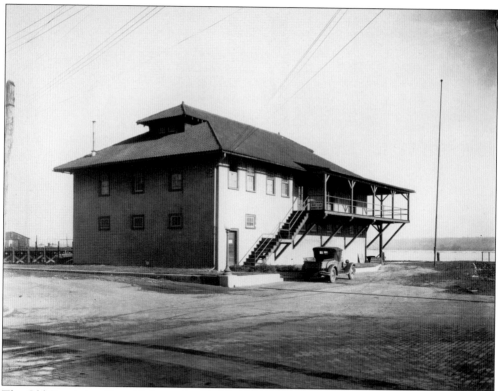

The Old Dominion Boat Club was founded on Alexandria's waterfront in 1880. Many members have become active in the historic preservation movement and made efforts to acquaint the public with activities around the Potomac River.

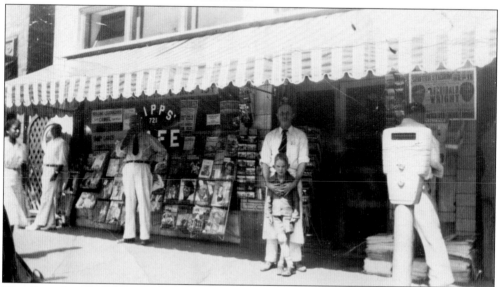

King Street has been the main commercial strip in Alexandria since the 19th century, with many small businesses catering to residents. Lipps' Café, at 721 King Street, was one such neighborhood institution. Only a block away from the USO club, it became popular with soldiers, sailors, and marines who came through Alexandria during World War II.

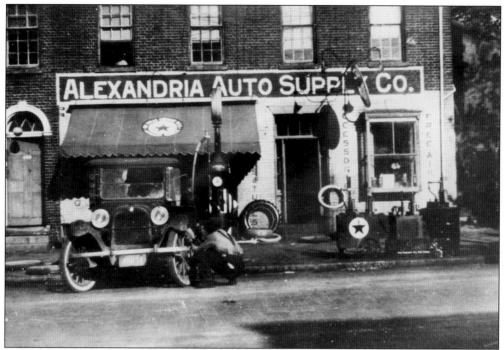

As the city entered the 20th century, new technologies found themselves squeezing in wherever possible. Frank Carlin's Alexandria Auto Supply, a Texaco supplier, had a small garage for many years at 104 South Washington Street, just up the block from the Confederate Monument.

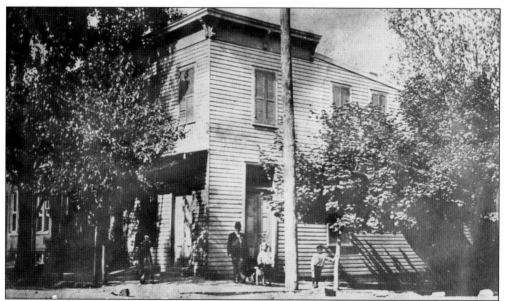

Because of its age, Alexandria has had mature trees for much of its later life. Here, at the corner of Pitt and Wolfe Streets, some of those trees give shade to a man watching children play with their dog.

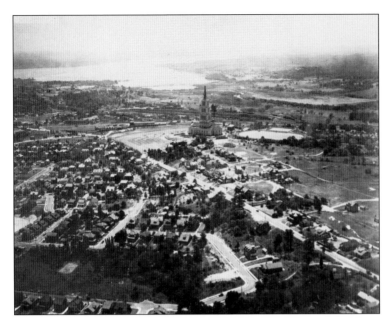

George Washington served as worshipful master in the Alexandria-Washington Masonic Lodge No. 22. The cornerstone for the George Washington Masonic Memorial was laid by Pres. Calvin Coolidge in 1923. After its completion, priceless relics belonging to the first president, including an original chair he owned, were installed.

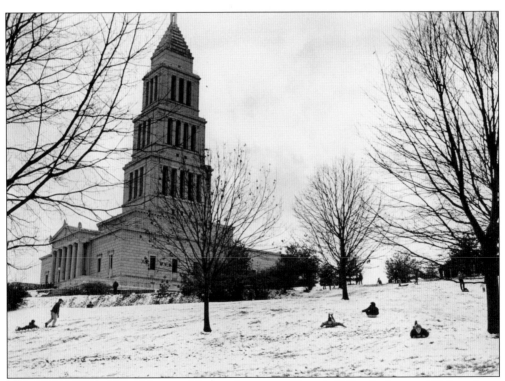

The George Washington Masonic Memorial sits atop Shuter's Hill, which rises 187 feet above King Street. During the Union occupation, it was the site of Fort Ellsworth, named for Col. Elmer Ellsworth, one of the first Union officers killed in the war.

Dr. Kate Waller Barrett (1857–1925) was a humanitarian, social crusader, and political reformer who received her medical degree in 1892. The widowed mother of six children, she was also active in war work, veterans' relief, women's suffrage, and the restoration of Arlington Mansion.

In 1937, Dr. Robert and Viola Tupper Barrett donated money for the construction of a library dedicated to the memory of Robert's mother, Dr. Kate Waller Barrett. The library was built on the Quaker Burying Ground after the city negotiated a 99-year lease with the trustees of the cemetery. The contract included assurances that the graves would not be disturbed.

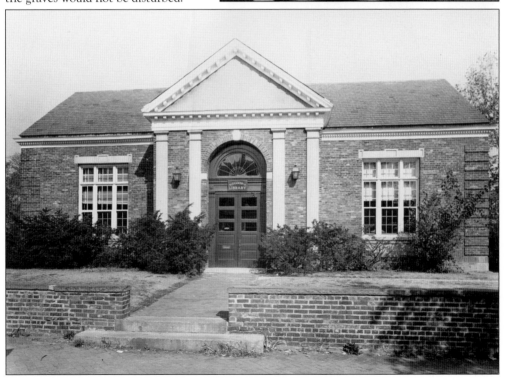

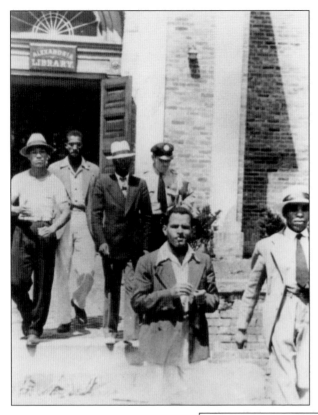

On August 21, 1939, five young men staged a "sit-down strike" at the whites-only Alexandria Library at 717 Queen Street. William Evans, Otto L. Tucker, Edward Gaddis, Morris Murray, and Clarence Strange entered the building and, one by one, asked to register for a library card. After each was refused, he sat and began to read a book. Librarian Katharine H. Scoggin called the police, who arrested the men for disorderly conduct.

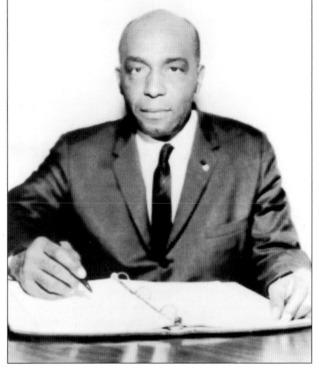

Samuel Wilbert Tucker (1913–1990), who grew up only two blocks from the library, graduated from Howard University and then read for the law. He tried for several years to establish equal access to community resources, but in the summer of 1939, the 26-year-old Tucker developed a new strategy and changed tactics. For weeks, he prepared the select group of five young men to stage the sit-in, a deliberate act of civil disobedience.

Samuel Tucker became seriously ill and was unable to pursue his quest for equal access. In 1940, community leaders proceeded without the young attorney's involvement and accepted the promise of a "separate but equal" library. Tucker was infuriated. The Alexandria Library Board quickly approved the construction of the Robert H. Robinson Library, appropriated funding for books, and hired an African American librarian.

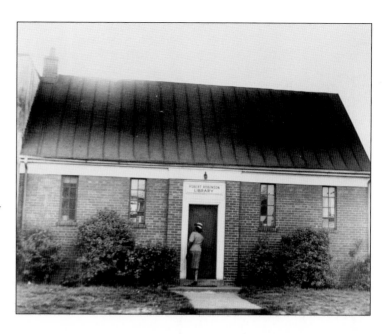

The Alexandria Black History Museum, devoted to exhibiting local and regional history, incorporates the Robert H. Robinson Library as one of two exhibition galleries. The library was originally constructed in 1940 after a sit-in at the segregated Alexandria Library.

The Departmental Progressive Club was founded in 1927 by seven African American men committed to improvement and progress through political and social reform. It is Alexandria's oldest private club. All seven were employees of departments of the federal government: Jessie

Carter, Lawrence D. Day, Clarence Greene, Raymond Green, Booker T. Harper, Jesse Pollard, and Samuel Reynolds.

Armistead Boothe's law career lasted from 1929 to 1970, with a two-year break while he served as special assistant to the US attorney general from 1934 to 1936 and a two-and-a-half-year stint in the US Navy during World War II. Boothe represented Alexandria in the Virginia House of Delegates from 1948–1956 and in the state senate from 1959–1964 after having served as city attorney in the early 1940s. His gradualist approach to desegregation appealed to many people.

Ferdinand T. Day was born in Alexandria in 1918 and was a big part of the civil rights movement in the 1950s and 1960s. In 1964, he was the first and only African American member of the school board. When he became chair of the board, he was the first African American chairman of a public school board in Virginia. In 1985, he was selected by the secretary of education to assist in the further implementation of the Virginia desegregation plan for higher education. Day retired from the US Department of State as a Foreign Service Reserve officer in 1978. He continues to advise and support Alexandria's leadership.

Four

Mid-20th Century to the Present

Alexandria experienced tremendous growth and transition after World War II. The expanding federal government required workers and office space. New people, new jobs, and new building projects were all part of the rush to modernize, which came very close to destroying the custom and character of the old town.

Alexandria's urban renewal plan, funded largely by the federal government in the 1960s, called for the tearing down of block after block of historic and architecturally unique structures to make room for modern buildings. Residents who treasured the past raised an outcry. In response to these concerns, the city council established the first public urban archaeology program in the country. Alexandria Archaeology, housed in the historic Torpedo Factory, is still a vibrant and citizen-friendly organization, preserving the past and teaching about it to schoolchildren, tourists, and scholars from around the world. Structures of particular historic interest such as Gadsby's Tavern and the Lyceum were set aside as city museums.

The momentum of preservation continued in the 1970s, as Alexandria Library amassed an extensive collection of historic city records, documents, and photographs. The Alexandria City Council established historical districts and passed strict laws to protect architecture from further encroachments.

Much of the city's past was saved by a generation of women whose husbands' careers bought them to the Washington area. While few of these women had professional historical training, they were willing to learn and share their discoveries. Women such as Ellen Pickering, Edith Sprouse, Madeline Green, Effie Dunstan, Ethelyn Cox, Ruth Baker, and Ruth Lincoln Kaye, to name just a few, have worked to preserve Alexandria's stories for the benefit of future generations.

The new millennium witnessed many changes in the old port city. A commitment to be more inclusive while honoring and preserving the past influences much of the city's decision-making. Just a few short years into the 21st century, Alexandrians elected their first African American mayor, the Alexandria Library Board appointed the first African American director of libraries, and Alexandria's first African American circuit court judge took the bench.

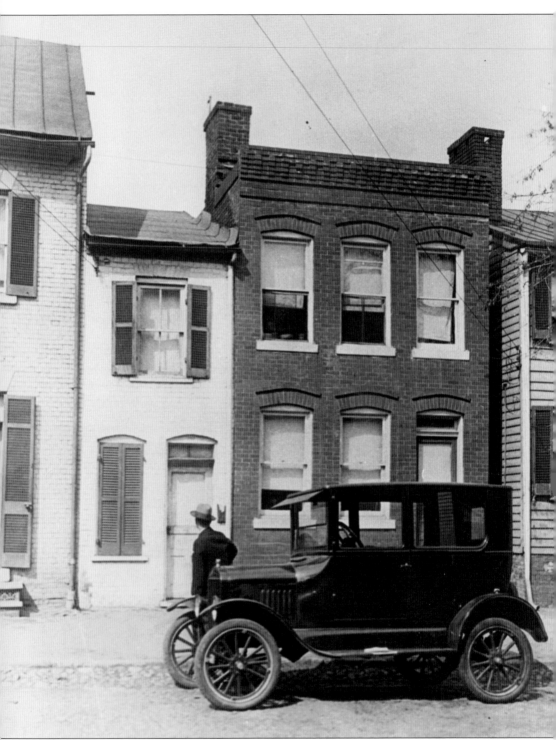

In the 1830s, local brick maker John Hollensbury needed more space for his daughters, Julia and Harriet. The enterprising Hollensbury used the adjoining alley as his building space, creating this house at 623 Queen Street. Just seven feet wide, it is the smallest house in Alexandria.

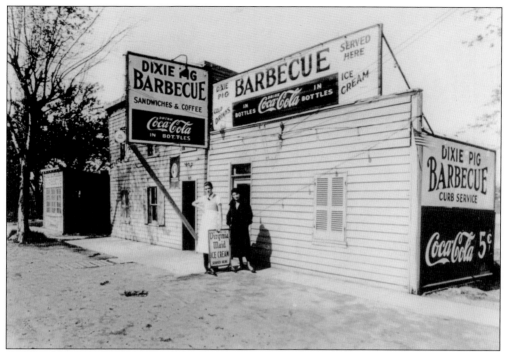

The first Dixie Pig Barbecue Restaurant opened on Powhatan Street in the 1920s. In business for decades, the roadside eatery was popular among travelers and residents. The building has been refashioned as a Greek restaurant.

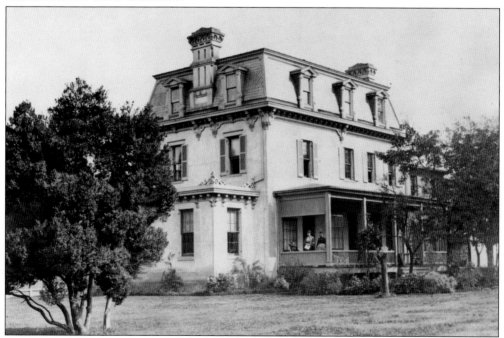

The Burke family has had a strong presence in Alexandria since the inception of Burke & Herbert Bank in 1852. The family has been intimately involved in with the bank since the beginning. Their beautiful manse at 208 Wilkes Street looked over the Potomac River.

On December 20, 1945, the Washington area dug itself out of a seven-inch snowfall, the heaviest December snowfall in 13 years. Municipal workers were out in force clearing streets and constructing impressive snow piles like the one this little boy has climbed on.

Once upon a time, at 324 King Street, on a block unfortunately lost to urban renewal, it was possible to get a haircut and a bath, most likely a popular convenience for men coming ashore from months at sea.

The old Cotton Factory at 515 North Washington Street has worn many hats over the years. Constructed before the Civil War, it has served as a hospital, battery factory, apartment building, and office building. Local legend associates the cupola with a ghost story.

The Cotton Factory building has perhaps been reinvented more often than any building in Alexandria. This image is from after its renovation and conversion to the Belle Haven Apartments.

Beck's Polar Bear at 901 North Washington Street, a popular teen hangout, sold confectioneries and frozen custard. One of the regulars was Willard Scott, familiar to morning show viewers as the ebullient weatherman on the *Today* show.

The Hot Shoppes restaurant chain began in 1927 as a roadside eatery. Founded by J. Willard Marriot, who later went into the hotel business, the Hot Shoppes at 905 North Washington Street was another popular place with local teenagers in the 1950s.

The Alexandria Roller Rink opened in November 1948 at Montgomery and North St. Asaph Streets. Its opening program included exhibition skating by national roller stars and a one-mile handicap speed competition. The venue had a capacity of 3,000 skaters, and an 11-ton, 25-horsepower Wurlitzer organ provided background music. In the 1970s, the rink struggled to survive, doubling as a rock concert venue before closing in 1979. It reopened in 1980 but closed for good in 1986 and was replaced with an office-hotel complex.

Jack Tulloch and Annie Dunbar attend the Alexandria Roller Rink celebration of Dunbar's 75th birthday in 1948. Jack Tulloch worked for the *Alexandria Gazette* from 1918 to 1951. Annie Dunbar took up sports at age 65, entering into a whirlwind of roller-skating, swimming, jitterbugging, and bicycling. She was a one-woman rolling promoter of the health benefits of skating and spent most of her evenings at the roller rink.

John L. Lewis was one of the most controversial Americans of the mid-1900s. He became president of the United Mine Workers of America (UMWA), helped found the Congress of Industrial Organizations (CIO), and was one of the most hated and feared men in Washington. Lewis fought hard for miners and millions of American laborers, and his aggressive tactics were legendary. He once called a coal strike in the middle of World War II. The Alexandria police frequently assigned officers to guard his home. (Library of Congress.)

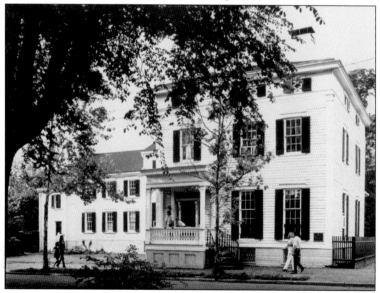

The Lee-Fendall House at 614 Oronoco Street is on land purchased by Gen. Harry "Light Horse" Lee after the American Revolution. Lee sold the lot to his cousin Phillip Fendall, who built this house in 1785. A Federal hospital during the Civil War, the property was home to John L. Lewis from the late 1930s until his death in 1969.

Hugo Lafayette Black was born and raised in the Alabama upcountry. He came to Washington as a senator from his home state and in 1937 was appointed to the Supreme Court by Pres. Franklin Roosevelt. Black loved history and was an avid reader. His tenure covered one of the stormiest periods in American history. Justice Black died in September 1971 and is buried in Arlington Cemetery.

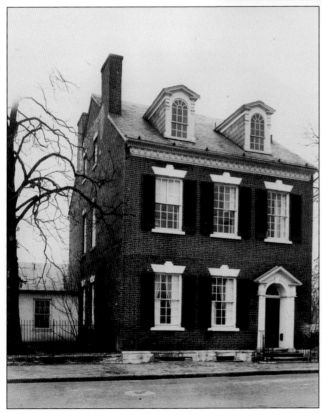

This house at 619 South Lee Street was built around 1800. The Vowells, a well-to-do merchant family, lived there for several years. The house was later occupied by Edgar Snowden, owner and editor of the *Alexandria Gazette*. In 1939, it was purchased by Justice Hugo Black, who lived there until his death.

The Benevolent Protective Order of Elks (BPOE) is a fraternal organization that started in New York City after the Civil War. The Alexandria Elks built this large hall with a sizeable verdigris elk at 318 Prince Street in the mid-20th century. By the 1980s, the property was converted to condominiums, but the elk still gazes out over Prince Street.

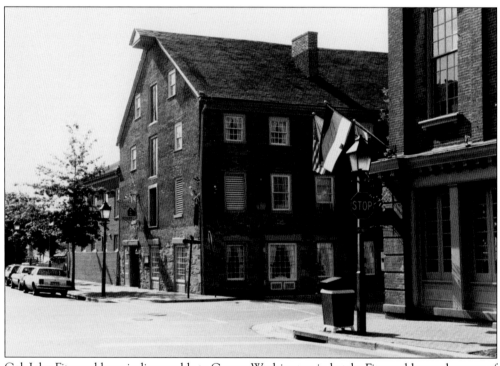

Col. John Fitzgerald was indispensable to George Washington in battle. Fitzgerald served as part of Washington's military family and after the war purchased this waterfront warehouse at the foot of King Street. Known as Fitzgerald's Warehouse, it stands opposite the Torpedo Factory. Fitzgerald served as mayor of Alexandria and was a leading member of the Catholic community.

In 1871, Temple Beth El Hebrew was constructed on the west side of the 200 North Washington Street block. Until 1956, when the temple relocated to a larger site, this was the center of Alexandria's small but vibrant Jewish community. After *Kristallnacht* in 1938, the temple was able to hire a rabbi from Germany to see to the needs of the congregation.

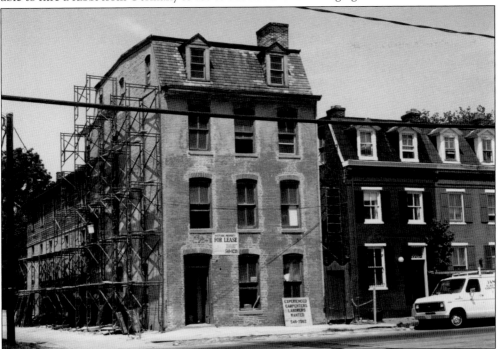

The property at 1415 Duke Street was originally constructed for a retired military officer after the War of 1812. In 1828, Isaac Franklin and John Armfield began their slave trade from this location and shipped more than 1,000 people a year to New Orleans and the Deep South. During the Civil War, the Union army used the facility as a military prison. In 1996, it was purchased by the Northern Virginia Urban League, which operates a museum at the house.

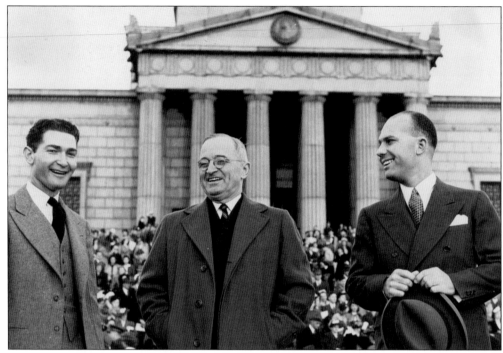

Pres. Harry S. Truman (center) stands in front of the George Washington Masonic Memorial on Shuter's Hill on a visit to Alexandria.

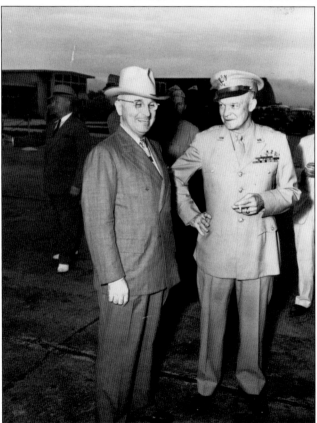

Pres. Harry S. Truman laughs with future president Gen. Dwight D. Eisenhower at Washington National Airport around 1945. Located just four miles from the capital, the airport was built on a plantation atop mud dredged from the Potomac River. Its proximity to the White House, the US Department of War, and the Pentagon made the airport an important tool for the US military.

Pres. Dwight D. Eisenhower (right) departs Christ Church, the first Episcopal church in Alexandria. Designed by James Wren, it was built from 1767 to 1773 by John Carlyle. George Washington and Robert E. Lee were regular worshippers. Other notable visitors include US presidents, Winston Churchill, and Bishop Desmond Tutu.

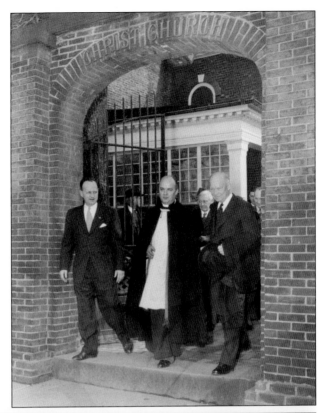

Sen. Gerald R. Ford poses for a photograph with Fairfax County police officers in the driveway of his Alexandria home on Crown View Drive. The senator represented Michigan for 25 years. Within a year or so of this photograph, he was named Richard Nixon's vice president after Spiro Agnew resigned his office due to criminal charges.

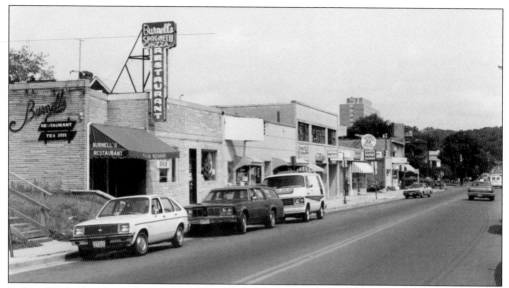

In June 1972, Hurricane Agnes stormed up the Chesapeake Bay, bringing massive amounts of rain and large tidal surges. In the Arlandria neighborhood of Alexandria, Four Mile Run flooded up to the second floor of some buildings, and much of the population was forced to evacuate. Since that event, the US Army Corps of Engineers has widened, straightened, and deepened the run to prevent future catastrophes.

Armistead Boothe was a racial gradualist and a man of conviction. Despite representing "Old Virginia" in his social and familial background, he was a person who believed in change and progress. He served in combat with the US Navy, was Alexandria city attorney, and also served in state government and as the head of Robert Kennedy's election committee in Virginia in 1968. Here Boothe prepares to be interviewed for television.

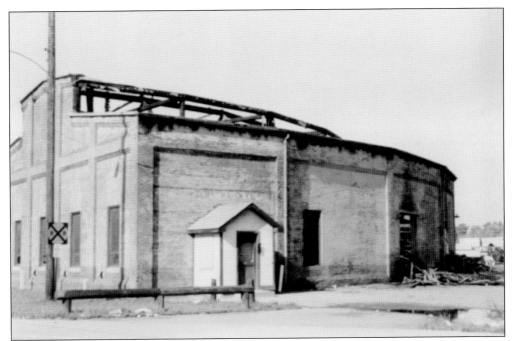

Alexandria had two railroad yards, Potomac Yards to the north and the Southern Railway yards to the west. In 1971, the largely abandoned roundhouse at the Southern Railway yards caught fire and burned. The land subsequently became a commercial site and was rebuilt with offices.

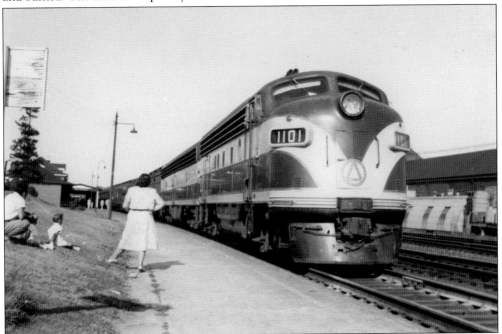

More than any other form of transportation, railroads connected Alexandria to the outside world. A new diesel locomotive at Alexandria's Union Station prepares to take passengers to points south. In just a few years, the growth of the interstate highway system and personal automobile ownership would cripple passenger rail service.

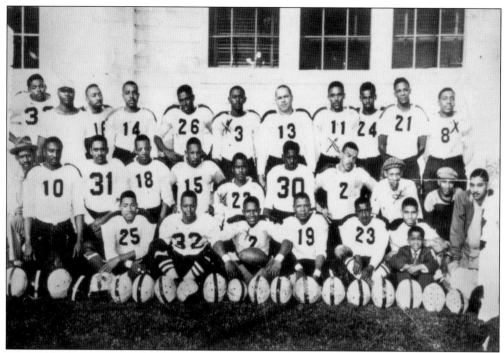

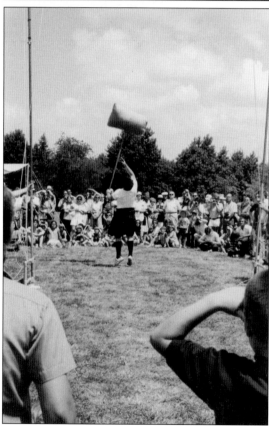

The Alexandria Rams, a semi-professional team, started in 1946. Ahead of its time, the team was integrated by 1951, when this photograph was taken.

The Scottish Games were established in 1974 as part of the Alexandria bicentennial celebration. In 2007, they moved to Sky Meadows State Park in Delaplane, Virginia. The gentleman in this photograph is "tossing the sheaf." Participants jab a pitchfork into an 18-pound bag of hay—"the sheaf"—and toss it over a horizontal bar 17 feet above the ground. The bar is raised until only one contestant remains.

In 1976, Betty Ford was the honorary chair of the Friends of Gadsby's Tavern. Here, she exits the museum after attending a meeting.

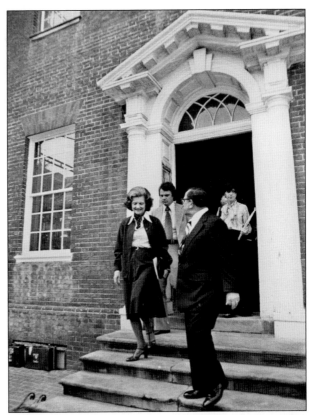

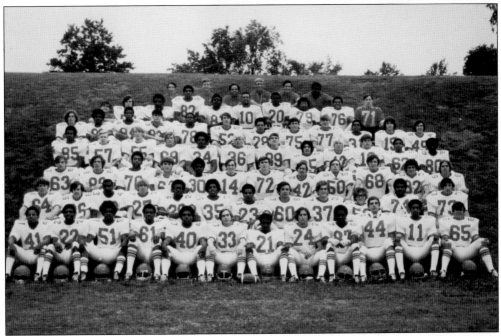

The 2000 film *Remember the Titans* was inspired by events that occurred at T.C. Williams High School in the early 1970s. It explored the themes of racism, discrimination, and athletics.

James M. Duncan Jr. (1897–1967) graduated from the University of Virginia in 1921 and served his city and state in various capacities. He was chief of the fire department, on the city council and library board, president of the Alexandria Chamber of Commerce, and director of the Virginia Chamber of Commerce. In 1969, the new Delray branch of the library was named after him.

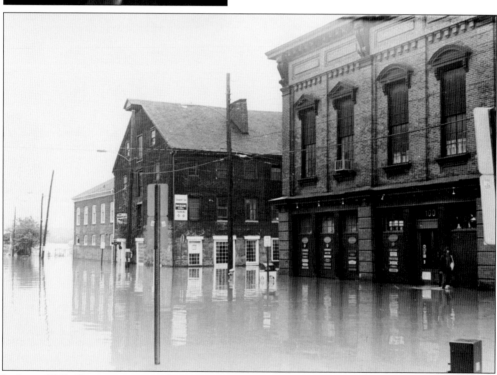

In June 1972, Hurricane Agnes hammered the city. As the Potomac crested, low-lying areas of Old Town were flooded. Five-foot deep floodwaters surged into Arlandria garden apartments, and residents were told to leave their homes. Telephone, electric, gas, and transportation systems were disrupted.

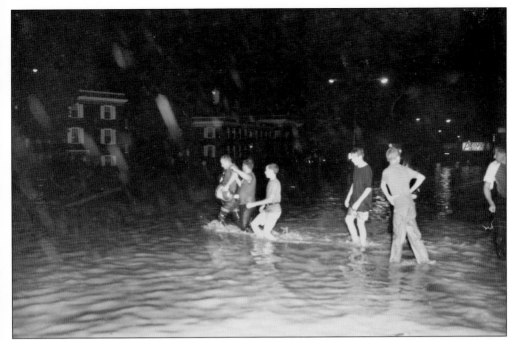

A small shopping center on Mount Vernon Avenue burned to the ground as the floodwaters hit, leaving firemen unable to reach the conflagration.

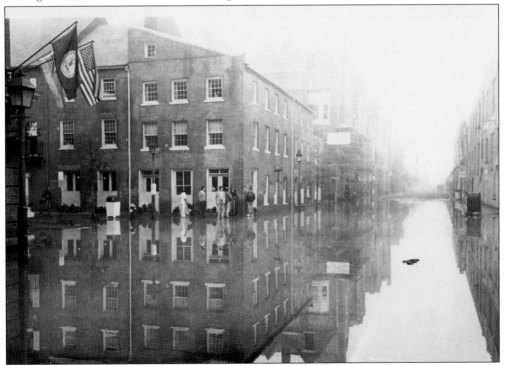

The Alexandria waterfront was claimed from the Potomac River during the 18th and 19th centuries. On occasion, the river has tried to take back its own. When a storm drops a great deal of rain and the winds drive the waters up the bay, the intersection at King and Union Streets floods.

Charles E. Beatley Jr. was born in Ohio and earned a master's in business administration from Ohio State University. His job as an airline pilot flying in and out of National Airport brought him to Alexandria. He went on to serve on the city council and then as mayor. In appreciation for Beatley's commitment to historic preservation and renewing the downtown business district, the central library was named for him when it opened in 2000.

Since the 1960s, Alexandria has been in a constant state of growth and renewal. Residents have learned, often ruefully, the importance of reading street signs, as rules are always changing.

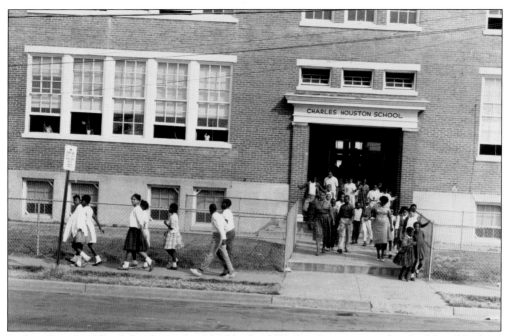

Parker-Gray Middle School, on the 900 block of Wythe Street, was a key building block in Alexandria's African American community. The school was one of the most important tools for local students to get ahead in life.

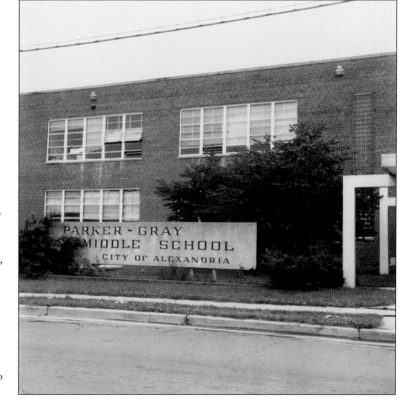

The old Parker-Gray Middle School, a monument to early African American education in Alexandria, closed, and in 1981, the property was sold off for commercial development. The Parker-Gray neighborhood and the school's many alumni continue to honor its memory.

The Alexandria waterfront has long been a combination of the old and the new. This modern fiberglass boat is moored next to an old wooden vessel that has seen better days. The continuing dichotomies of old versus new and rich versus poor continue to divide the city.

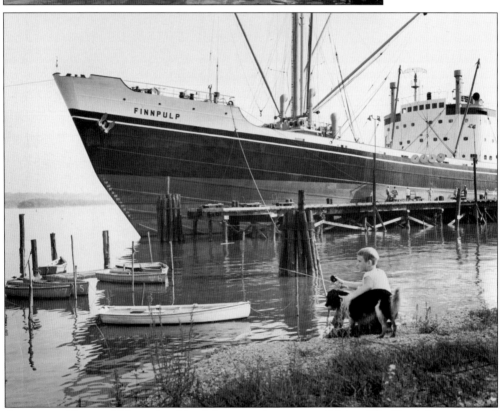

A young resident and his canine friend share a quiet moment fishing. The Finnish cargo vessel behind them, *Finnpulp*, helped change maritime safety. On the morning of November 13, 1965, the steamer USS *Yarmouth Castle* caught fire between Miami to Nassau with 552 passengers on it. *Finnpulp* and another vessel responded and rescued most of the passengers. *Finnpulp* was so close to the flames that her paint blistered. After the disaster, mandatory safety drills and safer construction methods were adopted for passenger ships.

The Ford Motor Corporation built a large production plant over the water on the Alexandria waterfront. The plant was never as successful as Ford hoped, and for many years it languished, a derelict structure on the water. It was torn down in the 1990s.

In 1947, Jack Franklin and Julian Whitestone established a rowing club at the Old Dominion Boat Club. This 1949 photograph of the George Washington High School (GWHS) crew team was taken at the Potomac River. Alexandria teams won national titles in 1954 and 1956 (GWHS) and tied in 1963 (Francis Hammond High School and Washington/Lee High School in Arlington). Alexandria high schools merged in 1971, and the T.C. Williams High School Titans won the national title in 1973 and 1981. Many local graduates have participated in the Olympics, including Fred Borchelt and Chip Lubsen Jr. in 1984 and Linda Miller and Nick Peterson in 2000. Charlotte Hollings went to the World Championships in 1994, as did Linda Miller in 1999.

The Red Cross Waterfront Festival took place in Old Town's Oronoco Park for nearly 30 years before its 2010 cancellation. This photograph from the 1983 event features a city council canoe race. Appearing in the photograph are then-mayor Charles Beatley and city council members Patricia Ticer and Marlee Inman.

The 1985 Red Cross Waterfront Festival featured 18 tall ships, including the Colombian training ship *Gloria*.

At the inaugural Alexandria Red Cross Waterfront Festival, thousands of people gathered. And a few of them took hot air balloon trips.

Another 1985 image of the Waterfront Festival shows sailboats and a hot air balloon.

Holmes Run is normally a small stream running through Alexandria west of Old Town, although sometimes the water level rises, meaning more fun for local children. Despite dredging and pollution problems, it continues to enhance the lives of locals.

Up until the 1960s, this space was occupied by buildings and stalls, many of which were in poor repair. The newer iteration of Market Square is an open space and features a year-round farmer's market—one of the oldest in the country—as well as celebrations and ceremonies throughout the year. While the space is certainly inviting, many Alexandrians lament the loss of the historic buildings that were once here.

Ellen Coolidge Burke (1901–1975) was born in Alexandria to a family that traced its ancestry to Thomas Jefferson. She was responsible for bringing one of the state's first bookmobile services to the city. Under her leadership, Alexandria Library grew to include two branches. Burke was a member of the League of Women Voters, the Urban League, and other civic associations.

A youthful William Euille, future mayor of Alexandria, plays a game of hoops at the local basketball court.

T. Michael Miller received degrees in history, political science, and international relations before being employed by the federal government and settling in Alexandria in the mid-1970s. Miller served as a curator of the Lee-Fendall House Museum and was a research historian for Alexandria Library. He lectured widely and published numerous articles and books before his retirement as city historian.

As a reporter for the *Alexandria Gazette* and WAMU radio, Michael Lee Pope is emblematic of a new generation of Alexandrians interested in their history. Originally from the Deep South, Pope came to Northern Virginia with a strong interest in history and culture and the journalist's kit of investigative tools. He has published two books on Alexandria's local history.

In 2003, the board of Alexandria Library hired Rose T. Dawson as its new director of libraries. She had already served the three previous years as deputy director. Dawson has become a library leader of national stature and continues to work as an advocate for libraries everywhere. Her tenure in Alexandria has overseen an increased level of commitment to the greater Alexandria community as well as greater cooperation between the library and other organizations and city agencies.

Pamela J. Cressey has been Alexandria's city archaeologist since the position was established in the mid-1970s. (Photograph by Nina Tisara.)

124

Alexandria has always had a town crier. In the early days, the crier announced news and information to the citizens. By 1784, Alexandria had at least one newspaper, and the town crier became less important. But in the 20th century, the position has been useful for public relations and special events. In 1983, this town crier announced that Metrorail was coming to Alexandria.

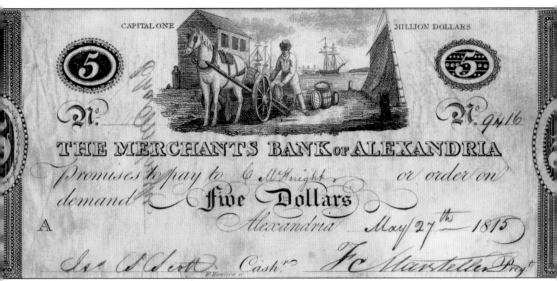

CAPITAL ONE

MILLION DOLLARS

5

5

№.

№. 9416

THE MERCHANTS BANK of ALEXANDRIA

Promises to pay to C. McKnight or order on demand Five Dollars

A

Alexandria May 27th 1815

Jno. S Scott Cash.r

Fc Marsteller Pres.t

Alexandria is in many ways a typical upper Southern community. But its proximity to Washington, DC, and its commercial connections to northern markets and ideas make the city unique. Over the years, the city has endeavored, not always successfully, to be more welcoming and accepting of the stories and histories that all its residents bring.

BIBLIOGRAPHY

Harvey, Karen G. and Ross Stansfield. *Alexandria: A Pictorial History*. Norfolk: Donning Company Publishers, 1979.

Kundahl, George G. *Alexandria Goes to War: Beyond Robert E. Lee*. Knoxville: University of Tennessee Press, 2004.

Madison, Robert L. *Walking with Washington: Walking Tours of Alexandria, Virginia Featuring over 100 Sites Associated with George Washington*. Baltimore: Gateway Press, 2003.

Merriken, John E. *Old Dominion Trolley Too: A History of the Mount Vernon Line*. Dallas: LeRoy O. King, 1987.

Munson, James. *Col. John Carlyle, Gent: A True and Just Account of the Man and His House 1720–1780*. Fairfax: Northern Virginia Regional Park Authority, 1986.

Patton, Julie Ballin and Rita Williams Holtz. *Historic Photographs of Alexandria*. Nashville: Turner Publishing Company, 2008.

Pope, Michael Lee. *Ghosts of Alexandria*. Charleston, SC: The History Press, 2010.

Powell, Mary G. *The History of Old Alexandria, Virginia: From July 13, 1749 to May 21, 1861*. Westminster, MD: Willow Bend Books, 2000.

Pulliam, Ted. *Historic Alexandria: An Illustrated History*. San Antonio: Historical Publishing Network, 2011.

"A Remarkable and Courageous Journey: A Guide to Alexandria's African American History." Alexandria: Alexandria Convention and Visitors Association, 2009.

Shomette, Donald G. *Maritime Alexandria: The Rise and Fall of an American Entrepôt*. Bowie, MD: Heritage Books, 2003.

Smith, William F. and T. Michael Miller. *A Seaport Saga: Portrait of Old Alexandria Va*. Virginia Beach: Donning Company Publishers, 1989.

Smoot, Betty Carter. *Days in an Old Town*. Alexandria: Reprinted by Ann Hopewell Hewitt Smoot, 1934.

"Walking Tour of Jewish Alexandria." Washington, DC: Jewish Historical Society of Greater Washington, 2009.

Winters, Barb. *Letters to Virginia: Correspondence from Three Generations of Alexandrians Before, During and After the Civil War*. Morley, MO: Acclaim Press, 2010.

DISCOVER THOUSANDS OF LOCAL HISTORY BOOKS FEATURING MILLIONS OF VINTAGE IMAGES

Arcadia Publishing, the leading local history publisher in the United States, is committed to making history accessible and meaningful through publishing books that celebrate and preserve the heritage of America's people and places.

Find more books like this at
www.arcadiapublishing.com

Search for your hometown history, your old stomping grounds, and even your favorite sports team.